IMAGES
of America

BRENTWOOD

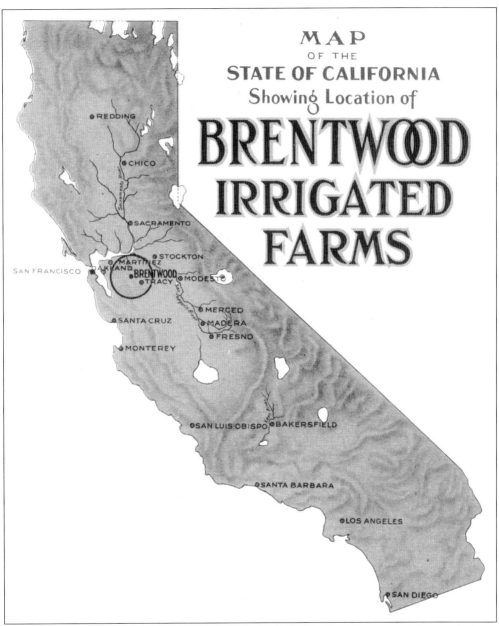

MAP
OF THE
STATE OF CALIFORNIA
Showing Location of

BRENTWOOD IRRIGATED FARMS

This relief map of the state of California features the location of Brentwood Irrigated Farms encompassing the modern city of Brentwood in eastern Contra Costa County. The 1930s Balfour, Guthrie and Company marketing brochure locates the city of Brentwood just 60 miles due east of San Francisco in Northern California.

ON THE COVER: The great Stone House, built by John and Abbey Marsh, is captured here by one of California's earliest photographers, Eadweard Muybridge (1830–1904). Marsh's son Charles and daughter Alice are among the Marsh family and friends pictured in 1870. (Courtesy of the Library of Congress, Historic American Buildings Survey, Gleason Collection, San Francisco College for Women.)

IMAGES
of America

BRENTWOOD

Carol A. Jensen
East Contra Costa Historical Society

ARCADIA
PUBLISHING

Published by Arcadia Publishing
Charleston SC, Chicago IL, Portsmouth NH, San Francisco CA

Printed in the United States of America

Library of Congress Catalog Card Number: 2007941843

For all general information contact Arcadia Publishing at:
Telephone 843-853-2070
Fax 843-853-0044
E-mail sales@arcadiapublishing.com
For customer service and orders:
Toll-Free 1-888-313-2665

Visit us on the Internet at www.arcadiapublishing.com

A single twig is weak and easily broken,
But many twigs together are strong.
United we create a bundle of strength and love.

Thanks, D. K. L., for being a part of the bundle!

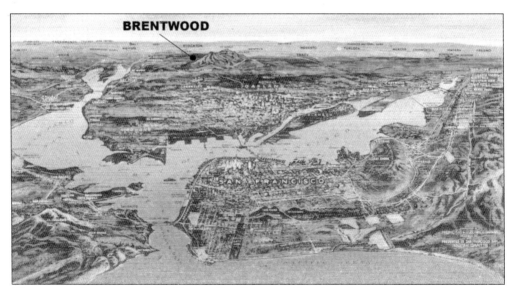

This metropolitan view of the Greater San Francisco Bay Area locates Brentwood as it peaks behind Mount Diablo. Brentwood lies on the extreme eastern boundary of the Bay Area Rapid Transit (BART) service area. Boasting the alluvial soil of the Sacramento and San Joaquin Delta, it touches the eastern edge of the Coastal Range. (Postcard complements of a private collector.)

CONTENTS

ACKNOWLEDGMENTS

This book would not have been possible without Kathy Leighton and the resource room of the East Contra Costa Historical Society. The Charlie Weeks Photographic Collection was particularly valuable. I am also indebted to the following organizations and their staff members: the University of California Bancroft Library, the Antiquarian Booksellers Association of America, the San Francisco Bay Postcard Club, and Liberty Union High School District. Gene Clare, principal of Liberty Adult Education, identified those Japanese Americans who were removed during World War II to internment camps prior to receiving their high school diplomas. Director Betty Maffei of the Contra Costa History Center and its Louis S. Stein Photographic Collection enhanced the quality and quantity of images included herein. The capable history center volunteers, especially William Mero, were a great help. The John Marsh Historic Trust Board and the Friends of John Marsh keep hope alive for restoration of the Stone House and promote the true heritage left to all Californians by Dr. John Marsh.

Warm appreciation goes to the following for providing family reminiscences and images: John and Elizabeth Mackenzie; Peter and Jane Wolfe and their daughters, Cathy and Ann; and Dr. Paul Krey, DDS. Thanks also to Mark White, who began this project and shared his aunt Edna Hill's family collection of photographs. Patty and Bill Bristow provided useful Brentwood Grammar School background. Charles Bohackle, who offers local history education for community college students, graciously shared his bibliography. Fraternal thanks to the Masonic Lodge, Order of the Eastern Star, and E Clampus Vitus. Thanks to John Poultney, Arcadia Publishing acquisitions editor, for his continuing interest in the growing communities in eastern Contra Costa County and the California Delta. The aid and patience of the irreplaceable Robert D. Haines Jr. cannot be overstated. He scanned and scanned until he could scan no more. Marcy Protteau, proofreader extraordinaire, once more applied her skill and offered her friendship.

All of the images in this volume are courtesy of the following institutions and individuals: East Contra Costa Historical Society; William Mero; Charles Weeks Photograph and Postcard Collection, East Contra Costa Historical Society; Contra Costa History Center; Louis L. Stein Collection, Contra Costa History Center; Mark White; Edna Heidorn Hill Collection; Byron-Brentwood-Knightsen Union Cemetery District; Mark McLaughlin, Mic Mac Publishing; Bill Wasson Photography; the Bancroft Library, University of California at Berkeley; Peter and Veronica Charitou, Sweeney's Grill and Bar; John and Elizabeth Mackenzie; Wolfe family collection; Liberty High School; Gene Clare, Liberty Adult Education; R. Paul Krey, DDS; coach William Ferrill; the family of Izumi Taniguchi; Bill and Kathy Leighton Collection; the Library of Congress; and various anonymous private collectors.

Finally, many local anecdotes were contributed from sources too numerous to list. I have made every effort to capture them correctly. Thanks to all for contributing to our collective local memory. Peter and Veronica Charitou, proprietors of Sweeney's Grill and Bar, are the spiritual heirs to Jimmy Torre. The images in this book are displayed in their Oak Street establishment for all to enjoy. The errors and omissions in the writing are all mine. Please contact me at the e-mail address Historian@ByronHotSprings.com if you can contribute to eastern Contra Costa County history with an oral history, family documents, letters, photographs, or ephemera.

INTRODUCTION

The rush for California gold in 1849 brought thousands of men and women West to mine and seek their fortune. The great Comstock Lode silver strike of 1859 transplanted these same men east and underground into the Virginia City hard rock mines. Men left their farming and husbandry lives "back in the States" in hopes of adventure, quick riches, and a new life in the mines. A massive demand for foodstuffs and the personal necessities of life was created in California's first years of statehood. This is the story of the community of Brentwood and how it has flourished as a provider of grains, field crops, and orchards. Along the way, its citizens built communities, worshipped, educated their children, served the public good, and had an enjoyable time all the while.

The vast California Delta is the largest alluvial plain in the country—second only in size to the Mississippi Delta. The indigenous people of the California Delta, who share a common Bay Miwok language, include the Julpun or Pulpunes people of the Oakley-Brentwood area. They organized into small groups or villages and lived in houses constructed of willow frames and thatched with tules or native grasses. They hunted abundant fish and game and gathered nuts, seeds, and plants, which provided sustenance. It is reasonable to estimate that in excess of 10,000 Native Americans dwelled in the greater delta out of the total state Native American population of between 280,000 and 340,000 in the late 1700s. The amount of indigenous people in the area can be appreciated by the number of those who perished from disease; Gen. Don Mariano Guadalupe Vallejo thought 70,000 Native Americans died from smallpox in 1833 alone.

The arrival in 1772 of Spanish explorers Fr. Juan Crespi and Capt. Don Pedro Fages, the mission system, and disease changed these Native American communities. Some submitted to the Spanish mission system by entering Missions Dolores and San Jose between 1806 and 1836. Others went deeper into the delta, forming a no-man's land that became the site of armed battles between Spanish troops and Miwoks who refused the foreign lifestyle. Secularization of the missions in 1836 threw "mission Indians" into the lurch. John Marsh provided employment for many on his newly acquired property, which he aptly named the Farm of the Pulpunes. However, by 1852, the U.S. Census was counting only 268 Native Americans in Contra Costa County

Those who grew weary of the mines, ran out of luck, or were worn out by the effort returned to the main economy of the nation: agriculture. By California's first census in 1860, more than half of the state's 380,000 citizens lived around the area known today as the Sacramento and San Joaquin River Delta. These individuals were cattlemen, dry wheat farmers, orchardists, vegetable farmers, and providers of other support services and teamsters to sustain an agricultural economy. Those remaining in California after the Gold Rush immediately embraced single-crop commodity farming on a large scale to supply the miners. The 10-acre subsistence farmer of Kentucky planting for family consumption and a small cash crop was unknown in California. Delta farmers would embrace what we have come to describe as agribusiness, replacing small family farms as the dominant model. The forty-niner drawn to the West found his true wealth in thousands of acres of grain and cattle sold to the burgeoning state mining population and to the international market for agricultural products. If Brentwood citizens could not pick up golden nuggets from the ground, they could make their fortune in a traditional manner by growing foodstuffs and marketing their products to those who remained in the mines.

The establishment of Brentwood, its agriculture, and its community experience speak to the larger topic of California agricultural history. More grain shipped through Brentwood for transshipment to Europe in 1877 than has ever been shipped before or since from any other port in the nation. Oscar Starr of Vasco developed the caterpillar-type track that revolutionized farm equipment. Balfour, Guthrie and Company and its successor organization, Brentwood Irrigated Farms, were sites of the first agricultural labor strikes, decades before the International Farm Labor movement. Japanese Americans, who established the Brentwood area as the foremost potato-farming area prior to the introduction of the russet potato, found themselves dispossessed of their property and relocated out of town on April 22, 1942, as World War II intensified.

Present-day Brentwood encompasses the surrounding rural communities now remembered only by road signs and memory. Sycamore Valley, Round Valley, Briones Valley, Arbor, Orwood, Eden Plain, Deer Valley, Bixler, Woodward, Point of Timber, Marsh Landing, Vasco, and Lone Tree were all small settlements or train depots. All were plucked from the vast Rancho Los Meganos, acquired by Jose Noriega in 1835 and purchased by pioneer John Marsh two years later for the equivalent of $500. Marsh believed his Mexican land grant included 50,000 acres from the eastern base of Mount Diablo on the west to the "tules land," San Joaquin River, on the north and east. The southern boundary encompassed the present-day Los Vaqueros Reservoir, just north of Livermore. The 1848 Treaty of Guadalupe-Hidalgo brought Mexican California into the United States and subsequent United States Land Commission action reduced this vast rancho to 12,000 acres by 1862. At this time, John Marsh had been dead by the knife of murderous assassins in Pacheco for six years. The Marsh legacy was left to his son, Charles, and little daughter, Alice.

Brentwood was formally identified as a town site in 1877 on land sold by James T. Sanford of the Brentwood Coal Company, the successor-owner of the vast Marsh land tract. Local legend holds that the Brentwood township name derives from the John Marsh ancestral family home in Brentwood, Essex, England. It may also refer to Brentwood (now the city of Holliston) in Sussex County, Massachusetts, Marsh's birth state. Finally, the name may pay homage to the town of Brentwood, Long Island, New York, the state from which the Brentwood Coal Company entrepreneurs originally hailed. I like to think Brentwood honors them all in a historical triple-entendre.

By 1900, Brentwood had a population of 200 citizens and was the largest permanent community in eastern Contra Costa County. Only Byron could exceed that number on any particular day if the many visitors enjoying curative waters at the Byron Hot Springs resort were included. Slowly, the one- and two-room schoolhouses at Liberty, Deer Valley, and Lone Tree were consolidated into Brentwood School. Families from Bethel Island, Oakley, Knightsen, Byron, and Brentwood established Liberty Union High School, which graduated its first student in 1906. The city of Brentwood proved the economic, educational, and community anchor for the east county, culminating with its 1948 city charter and incorporation.

Brentwood captures the marshland experience enjoyed by Native Americans, explored by de Anza, reclaimed from seasonal flooding, and finally brought into agricultural production to feed the world. Along the way, communities have been built, family dynasties created, industrial patents secured, children born, and graduating classes matriculated. The life experiences, streets, and social institutions enjoyed by those living in Brentwood as late as 1970 were much the same as those of the community 50 years earlier. This volume hopes to capture the flavor of living in a small California Delta town. Once upon a time, there were no stoplights; the closest cruise route was a 8-mile drive to Antioch; a summer job was cutting apricots for drying; and fast food was a burger at the Lion's Den.

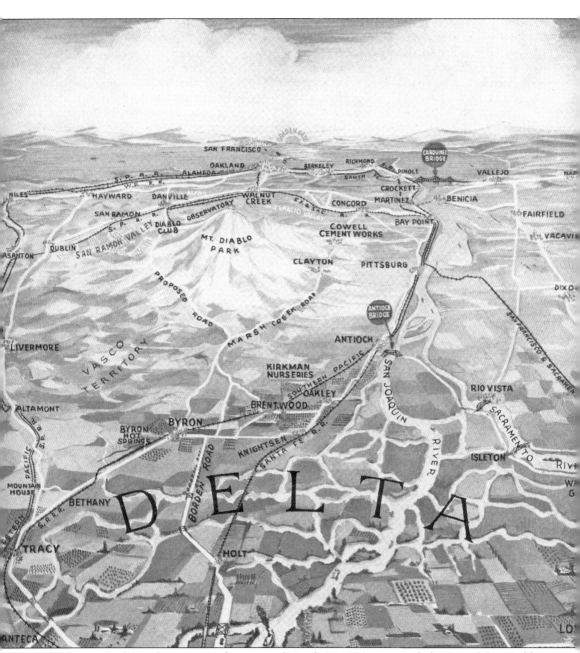

The famous Saul Steinberg *New Yorker* cover of March 29, 1976, was entitled "View of the World from 9th Avenue." Here the *Byron Times* has anticipated Steinberg's illustration by 40 years. The lower half of the image shows Brentwood and the world east of Mount Diablo. West of the mountain lie the cities of Oakland and San Francisco. The rest of the unknown world lies beyond the Golden Gate.

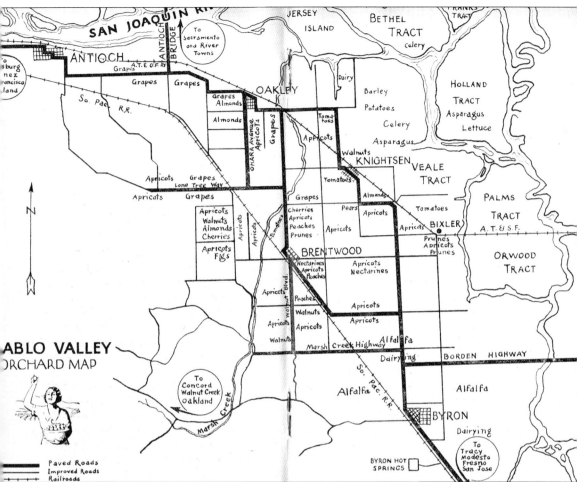

The Brentwood area was considered the Diablo Valley from 1900 to 1940, before the communities of Walnut Creek, Concord, and Pleasant Hill assumed that moniker. This 1930 map from the Diablo Valley Yearbook focuses on the orchards, row crops, and grain that have been hallmarks of Brentwood since 1910. Note the pride taken in the key transportation routes highlighted in the map legend: improved roads, paved roads, and railroads. All roads led to the Fifth Annual Apricot Festival, held in Brentwood on June 27, 28, and 29, 1930.

One

EARLY YEARS
RANCHO LOS MEGANOS

The early years at Rancho Los Meganos established the crops and population that would define the state. Marsh introduced wheat, viticulture, orchards, dairy, and cattle ranching to the Central Valley. His letters and efforts to encourage emigration from the United States to Alta California resulted in the first overland party of settlers, the Bartleson/Bidwell party, arriving in California at Marsh's rancho in 1841. Marsh worked tirelessly behind the scenes for a peaceful transition of Mexican California into the United States. The Mexican-American War, gold discovery, and the Treaty of Guadalupe-Hidalgo would change California's political climate and Marsh's personal fortune, culminating in his murder in 1856.

Economic realities changed after California joined the United States in 1850. Taxes were levied, and payment in legal tender—not goods—was expected. Record keeping and accounting became important. Gone were the days where a generous Californio grandee could barter and trade with cattle hides while making benevolent gifts to friends. As land commission court cases flourished and squatters made claims, taxes had to be met and attorneys paid. Charles Marsh, the son and heir of John Marsh, thought he saw a way to free himself from these crushing financial burdens. Coal mining began in earnest.

By 1868, considerable effort had been made to develop a commercial coal mine on Rancho Los Meganos. A mine site had been established early on for commercial-grade pottery clay, providing materials for an Antioch Pottery manufacture. Miners displaced as the Virginia City Comstock Lode "Big Bonanza" came to a close found employment in the coal mines of eastern Contra Costa County. Chinese, Cornish, Welsh, Portuguese, and Yankee miners enjoyed continuing employment here. These "black diamond" mines provided more than 47 percent of the energy consumed in 1868 by San Francisco industry alone. The bituminous coal was inferior to the quality-grade anthracite coal mined in the eastern United States.

By 1872, Charles Marsh had defaulted on a loan made by the Savings and Loan Society of San Francisco, and the bank secured by the entire 14,000-acre Rancho Los Meganos. John F. Williams and James T. Sanford of New York, in the name of the Brentwood Coal Company, acquired the property and expended considerable effort to bring the mine into commercial coal production. That company then also defaulted on trust deeds and development loans secured by the property and by Charles Marsh and the Savings and Loan Society of San Francisco. The Brentwood Coal Company declared bankruptcy in 1878. The bank engaged a resident property manager/leasing agent to handle the bank's farming interest. The land was subdivided and leased for dry farming of wheat and barley while litigation over the property, coal mine shares, and heir rights ensued. Litigation, which had plagued the property since John Marsh's death, continued for the next 22 years.

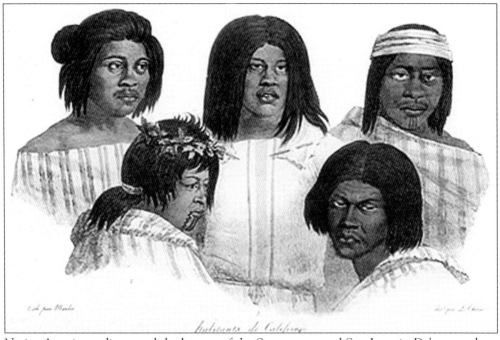

Native Americans discovered the bounty of the Sacramento and San Joaquin Delta as early as 9000 BCE, according to recent archeology. The indigenous people in the area, part of the Bay Miwok language group, are variously named Julpuns by contemporary scholars or Pulpunes by the European American settlers of the 19th century. Distinctive face tattoos, like that of the person on the lower left, uniquely identify Julpuns.

Creating an inland sea from the San Joaquin River to present-day Antioch, the marshland would have been pristine for Native Americans. Pronghorn elk, grizzly bears, deer, beaver, muskrats, reeds, roots, oak trees, shellfish, and fish abounded. Current evidence of grinding rocks used for mashing acorns, shell mounds, and burial cairns are all that are left.

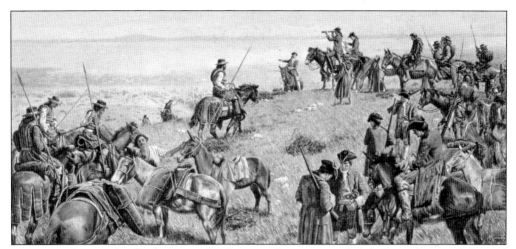

Franciscan friars under the direction of Fr. Junipero Sierra superseded the Jesuit friars and planned an expansion of the mission program to Alta California. Spanish explorers Capt. Don Pedro Fages and Father Crespi were sent north from Mexico City to explore the San Francisco Bay and reconnoiter at the edge of the delta in 1772. Those Native Americans fleeing the mission system would penetrate even more deeply into the delta and resist any attempt at capture.

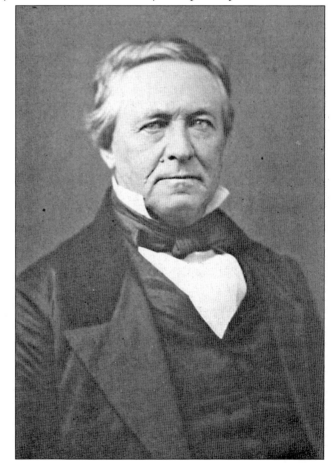

Into the Mexican-American no-man's land of the California Delta entered Harvard-educated mountain man, explorer, tradesman, and frontier medical doctor John Marsh (1799–1856) of Massachusetts. Marsh purchased 11 leagues of land from Don Jose Noriega for the equivalent of $500 in cattle hides in 1836. No European American dared reside in the great Central Valley for fear of the dangerous Pulpunes and former "mission Indians."

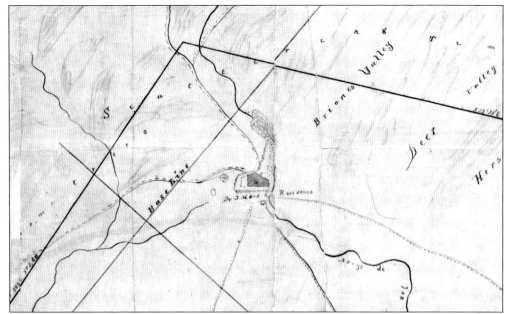

Marsh was intrepid in establishing his permanent residence and farm in the heartland of Alta California. He arrived to find the reputedly dangerous Native American tribes passive and suffering from malaria. Medication, quinine, and careful nursing earned Dr. Marsh gratitude and loyalty.

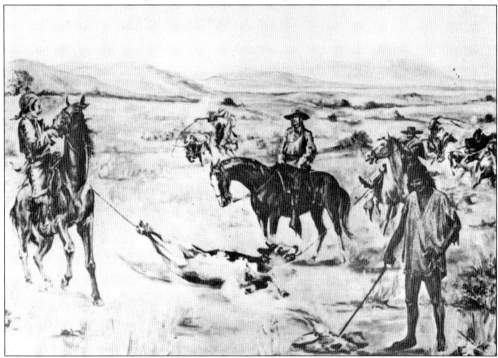

John Marsh's arrival in the delta was fortuitous for both parties involved. The Spanish missions were secularized in 1836, releasing hundreds of novitiate mission Indians to their own devices. Many were trained in animal husbandry, farming, and construction. Marsh placed these skills to immediate use in creating what he named the Farm of the Pulpones.

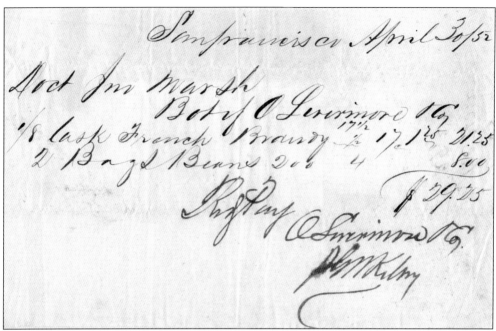

Man does not live by acorn bread alone. Marsh made trips into San Francisco for the necessary supplies of civilization. This receipt, dated April 30, 1852, and drawn on the Bank of Livermore, San Francisco, paid for two bags of beans and a one-eighth cast of French brandy. The educated, multilingual, and visionary Marsh brought the trappings of civilization to Los Meganos.

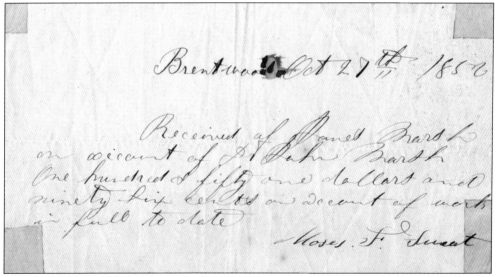

Los Meganos soon became less of a remote outpost as commercial trade occurred with the States and on credit account. Dated October 27, 1852, this receipt was drawn to a tradesman in Brentwood, New Hampshire; Brentwood, Massachusetts; or Brentwood, Essex, England. Daniel Marsh was John Marsh's brother, and the date of this receipt predates the founding of Brentwood township by 25 years.

The real danger at Rancho Los Meganos was not the Pulpones inhabitants but rather the bandits, raiders, and renegades. One of the most prominent was Claudio Feliz, Joaquin Murrieta's brother-in-law. After spending a pleasant afternoon as a guest of John Marsh on December 5, 1850, Feliz returned with a dozen outlaws armed with guns and lances. They overran the rancho, captured Marsh, looted the adobe ranch house, and speared to death William Harrington, an unresisting Anglo visitor. The bandits escaped with $300, gold watches, and guns. (Drawing complements of William Mero.)

Marsh tempered the violence on the frontier with intellectual pursuits and literary enrichment. John Marsh was a Harvard-educated man from a cultured Massachusetts family with ancestral ties to England. Even at this California Delta outpost of civilization in the midst of the Gold Rush, he maintained a subscription to four of the leading reviews and journals of the era.

Previously married and widowed, John Marsh found domestic happiness with Abigail Smith Tuck in 1851. After 20 years pioneering on five U.S. frontiers, Marsh had become a powerful and wealthy player in the new state. His rancho reputedly had the largest cattle herd in California at 6,000 head—all destined for hungry Sierra Nevada miners.

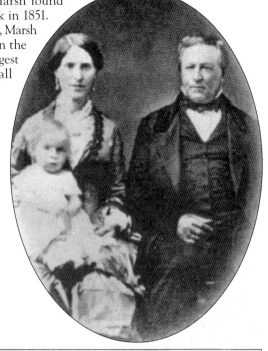

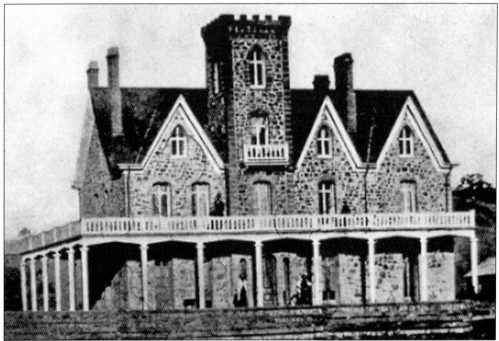

John and Abigail Marsh planned a home befitting their new life and John's new stature. There was even a ground-swell movement to elect Dr. Marsh governor at the next general election, slated for 1859. The house would have seven gables, a reference to the novel by Nathaniel Hawthorne. Thomas Boydand was engaged as architect, with work beginning in 1855. An architectural gem, this house was the first of its kind built in the state.

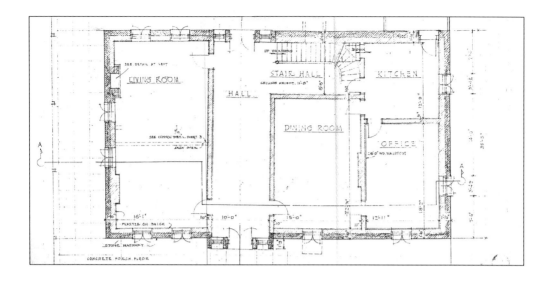

The floor plans for the great Stone House document the first house of its kind ever built in California. The large home bears rectangular proportions of 36 by 60 by 40 feet to the ridge of the roof. The interior walls of plastered brick stack straight up from the first (above) through the third levels. The second level (below) is dominated by a suite of bedrooms separated by a large door and a pair of his and her closets. This bedroom suite, sitting directly above the parlor, includes the same amenities of fireplaces and access to the top level of the veranda. The single bathroom of the house opens off the second-level stair hall. The second-level ceiling height is 10 feet, as are the flat portions of the third level.

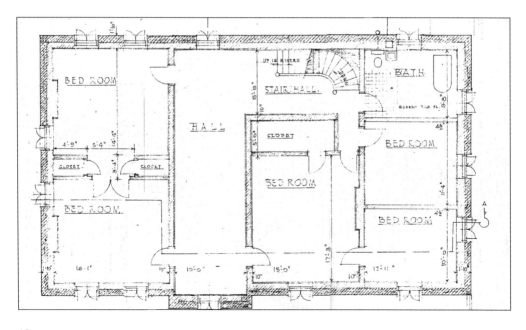

18

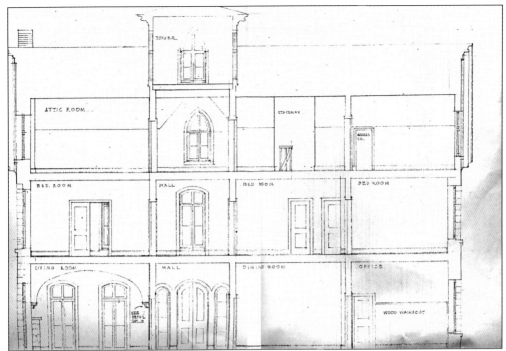

The third level consists of three rooms. The graceful but low-headroom stairway enters into a central space leading to a ship's ladder–like access to the tower. This space has small balconies opening to the east and west. The tower is open air with a high crenellated parapet, over which there is a 360-degree panoramic view from the delta waters to the foothills of Mount Diablo.

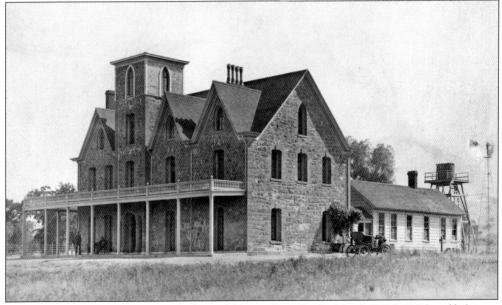

This original silver print captures the beautiful home that Charles Marsh (1826–1901) and his sister, Alice (1852–1927), inherited from their father, John Marsh. The unnamed photographer stands in the entry with his tripod and camera. Does his assistant snap the photograph? Abigail never lived in the home, and John did for only three months before his 1856 murder in Pacheco.

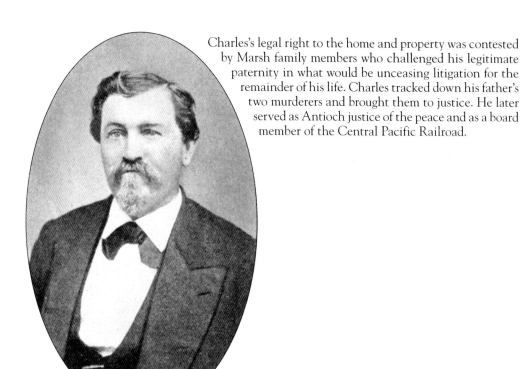

Charles's legal right to the home and property was contested by Marsh family members who challenged his legitimate paternity in what would be unceasing litigation for the remainder of his life. Charles tracked down his father's two murderers and brought them to justice. He later served as Antioch justice of the peace and as a board member of the Central Pacific Railroad.

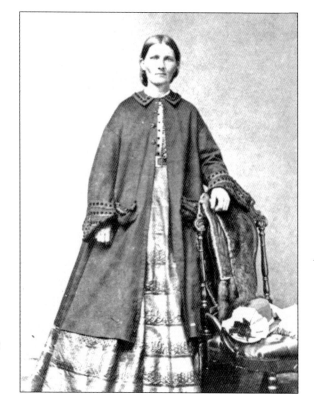

Once established at the Marsh rancho, Charles sent to Illinois for his wife, Susan (Panitier) Marsh, and their seven children. Charles was the offspring of John Marsh and his Sioux-French wife, Margarite Decouteaux, of Prairie du Chien, Minnesota. At the death of his mother in childbirth, Charles was left to be raised by the Panitier family in New Salem, Illinois. He and Susan had naturally found each other.

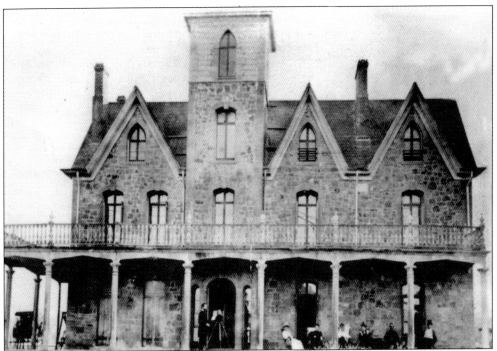

Intended for John and Abigail Marsh, the great Stone House finally became the home for Charles and Susan. This image, dating after the 1868 earthquake, show the restored tower without its distinctive crenellations. Rising 47 feet, the large tower suggests the potential for defensive use. A 10-foot-wide veranda encircles three sides of the house. Access is made available from the first and second levels through full-height French windows. The veranda provides welcome shade and rain protection. The aesthetics of the tower and veranda are further enhanced by the views they would have provided to Marsh as he surveyed the activity of his vast rancho.

HALL OF THE SOCIETY OF CALIFORNIA PIONEERS.

N. E. Corner of Gold and Montgomery Streets.

Charles Marsh eventually took his father's place in California as a member of the newly formed Society of California Pioneers, the brainchild of early Californian Mariano Vallejo. This society, founded by those living in California before January 1, 1850, would go far to create the romantic early history of California. Unfortunately, John Marsh died before his true contribution to the state could be immortalized in a memoir.

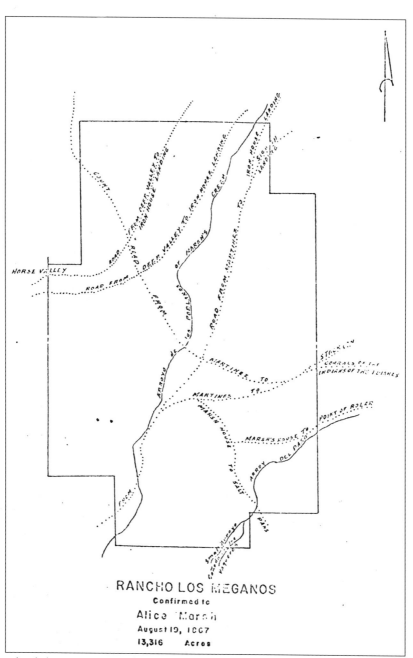

RANCHO LOS MEGANOS

Confirmed to

Alice Marsh

August 19, 1867

13,316 Acres

Litigation, land claims, cross complaints, and sharecropping disputes—as well as further reduction of what John Marsh believed to be included with his 50,000-acre property—continued to plague his heirs. Final resolution of ownership did not occur until the Whitney Survey was completed, the boundaries surveyed, and the findings detailed by the U.S. Land Commission on August 19, 1867. Baby girl Alice (Marsh) Cameron, now grown to young womanhood, and Charles settled for 13,316 acres after the property was clearly surveyed. The liens and trust deeds securing debt continued, but the attorneys and creditors were more confident in the perfection of their claim against the Marshes' real estate assets. Settlers began to establish farms in earnest on the margins of the Marsh Grant.

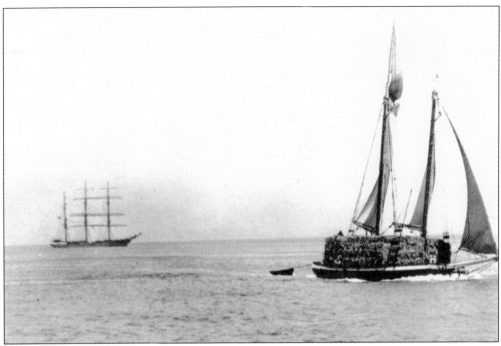

Commercial dry farming of wheat grain in the lower California Delta accelerated despite the trials of the land court. John Marsh's introduction of cultivated wheat grass in 1837 found a natural home in the upper San Joaquin Valley. Brentwood area farmers commercially harvested wheat growing naturally and sent it to the San Francisco hay dock for the first time via hay scow in 1862.

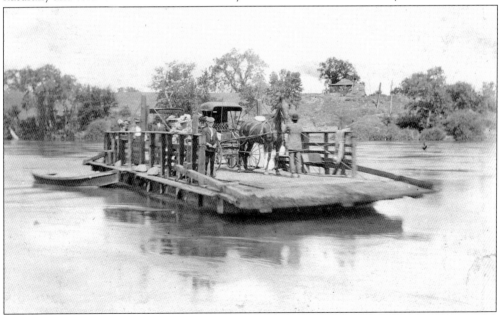

Point of Timber and its landing at Indian Slough provided a water route to the main San Joaquin channel starting in 1883. Land transportation to commercial markets was impossible until the advent of the railroad, the eventual draining of marshland, and the creation of levees. Point of Timber Landing provided an alternative to the railroad transportation monopoly.

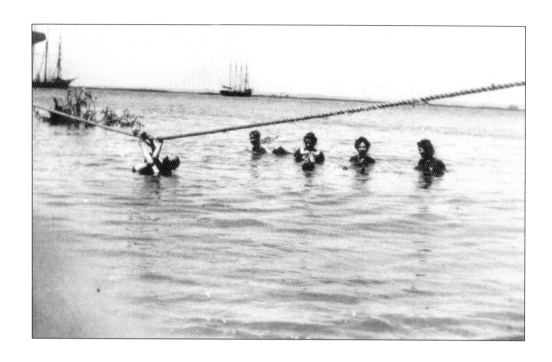

Part of the commercial advantage of Marsh's Rancho Los Meganos was its proximity to a deepwater channel. Here girls frolic in the water (above), and people fish from the dilapidated wooden pier (below) at Marsh Landing, along the upper San Joaquin River just west of the present-day Antioch Bridge. Established in 1854, this was one of the earliest commercial landings for transshipping agricultural goods to the gold mines and later to deep-hulled oceangoing sailing ships. Three-mast schooners stand offshore, awaiting an opportunity to load. Marsh employed a landing master to reside at the landing; otherwise, he would have intimidated or litigated others to leave his property.

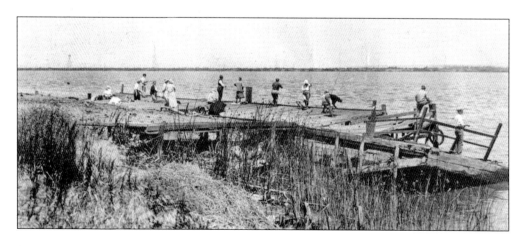

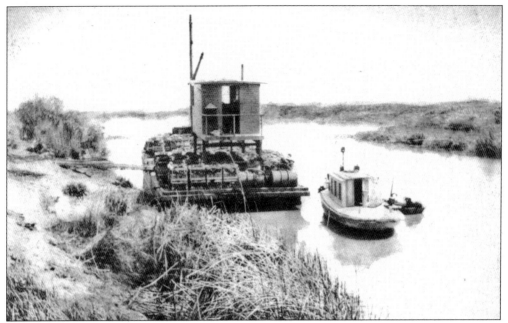

Point of Timber Landing, established at the very edge of eastern Contra Costa County in 1883, was a main point of agricultural product transport. Shallow-draft barges and ferries took on cargo here, on the very margin of Indian Slough. This small-tonnage craft carries crates of celery. The large dog in the rowboat emphasizes the dollhouse size of these boats.

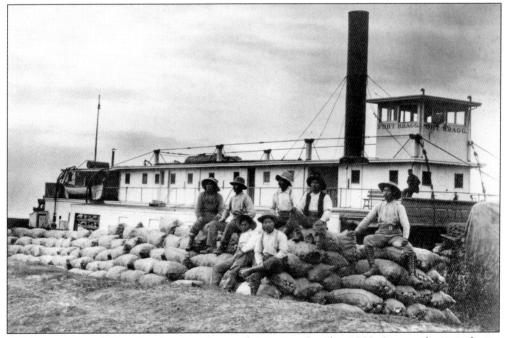

The ferry transport *Fort Bragg* awaits a cargo of onions in October 1909. Among the men shown here are the four Japanese bosses—M. Tsuda, S. Shimamura, Takaki, and H. Uintsu—and their men. Note that the onions are picked by hand and transported in burlap bags—no tractor here, only strong backs. (Courtesy of the Edna Hill Collection.)

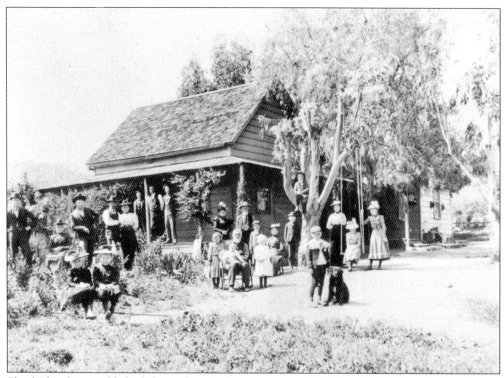

Slowly families established themselves in the east county, forsaking the Mother Lode mines of California and Virginia City or emigrating directly from the east. Diffin family members, pictured in front of their Briones Valley ranch home in 1897, represent three generations of prosperity. The grandfather holds the baby.

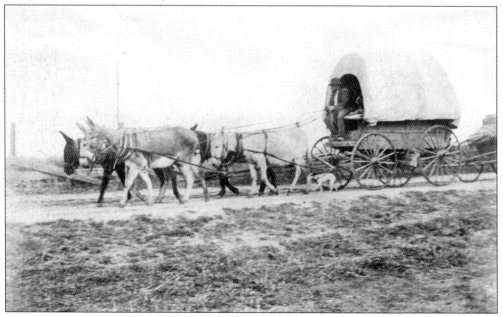

One of the last horse traders to journey through the east county area travels by horse and covered wagon before the advent of trains and automobiles.

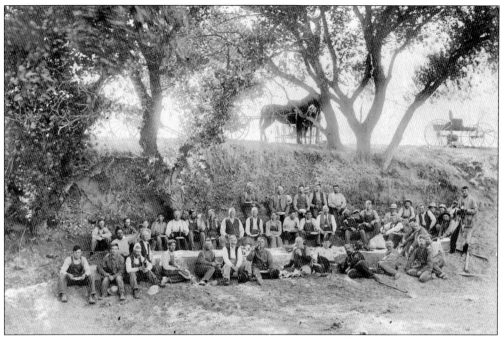

A volunteer road construction crew stops for lunch along Marsh Creek in 1905. The creek was the source of rock used for graveling most of the roads in the area. This load was destined for Lone Tree Way. Early settler Ed Prewett sits in the first row, sixth from the left, while his brother Joe Prewett sits 12th from the left.

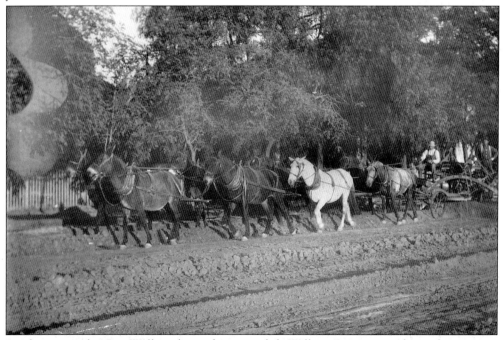

Road crew member Ray Wallace drives the team while William Dainty runs the grader, creating the new Dainty Way. Dainty Way leads two miles out of town and past the Dainty home on Marsh Creek.

Joe Carey was Brentwood's first blacksmith. Originally settling in Point of Timber, he moved to Brentwood in 1874, four years before the San Pablo and Tulare Railroad arrived. He must have known the railroad was coming, as he strategically placed his shop where the Brentwood Funeral Home is today—two blocks from the railroad tracks.

P. J. (Jack) Moody, who opened the second blacksmith shop in Brentwood in 1883, poses for an 1891 photograph.

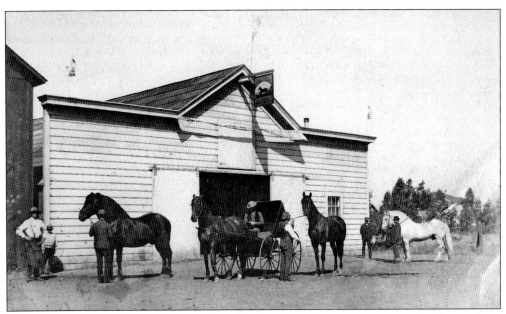

The Brentwood Livery Stable proudly displays its draft animals in 1890. Vlad Moody stands on the left. Next door on the left is the blacksmith shop built by Joe Carey and subsequently sold to Moody, who ran both establishments from 1884 to 1894.

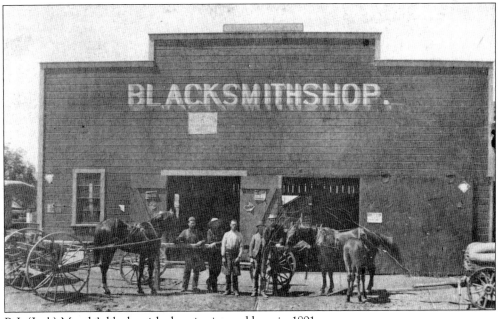

P. J. (Jack) Moody's blacksmith shop is pictured here in 1891.

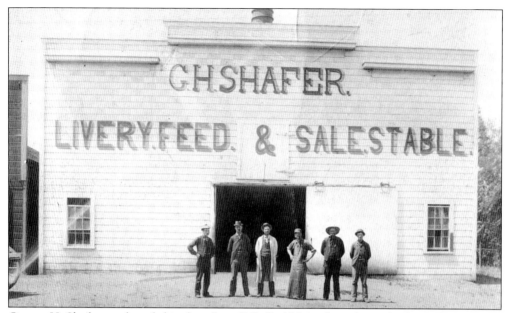

George H. Shafer purchased this shop from P. J. (Jack) Moody and ran the livery for 25 years, buying and selling livestock and grain. Shafer also served as constable, coroner, and undertaker. He and his wife, Elizabeth, were state-licensed morticians and established the funeral home adjacent to the livery in 1905.

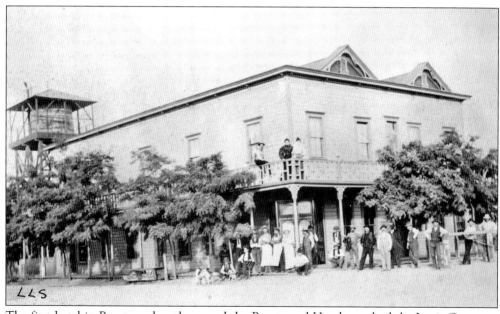

The first hotel in Brentwood, aptly named the Brentwood Hotel, was built by Louis Grunauer in 1884. It was the town's only hotel until 1903, when a disgruntled past employee started a fire in the basement storage area and burned it to the ground. Grunauer built the first mercantiles in Brentwood, Byron, and Tracy.

This 1900 view looks north from the railroad depot, showing Oak Street in downtown Brentwood. Note the location of the first Brentwood Hotel, located at the corner of Oak Street and Brentwood Boulevard, where the Chevron gas station is located today..

Prosperous citizens and land speculators Nick Harris, C. B. Harris, and Dudley Harris arrive in Brentwood and walk across the tracks from Oak Street on March 6, 1898. The men are assessing the opportunities for financial gain from real estate transactions or commercial business. They are not prospective farmers.

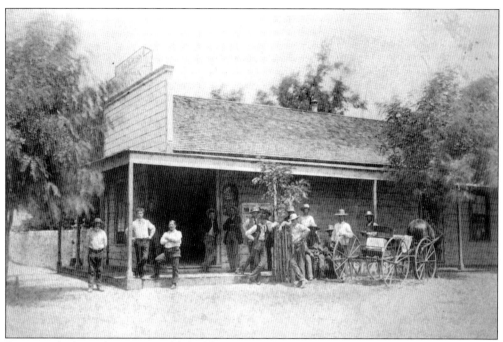

Brentwood's first saloon was established by E. Bacigalupi in 1876. The Grunauer mercantile store may have been the first in town, but a saloon to drink a shot of Argonaut whiskey and a 4¢ beer was not far behind. By World War II, Brentwood had seven saloons between the city park and the railroad station. The town was a favorite for soldiers stationed at Camp Stoneman in Pittsburg awaiting orders to ship oversees.

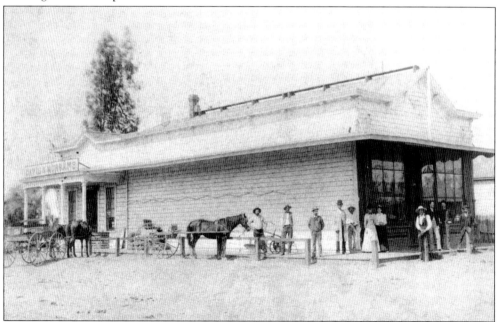

Shown here is one of the first three stores in Brentwood, the Davis and Morgan Mercantile store on Oak Street, around 1880. Here one could purchase the necessities of life: ready-made clothing, shoes, cooking equipment, stoves, notions, stationery, soap, and kerosene.

Jim Torre built this duplex residence next to his saloon on Oak Street. Pictured from left to right are Jenne Torre, Mrs. DeMartini, Mae (Torre) L'Heureux, and Jim Torre. Torre's saloon watered men at the bar inside and horses at the trough outside the door.

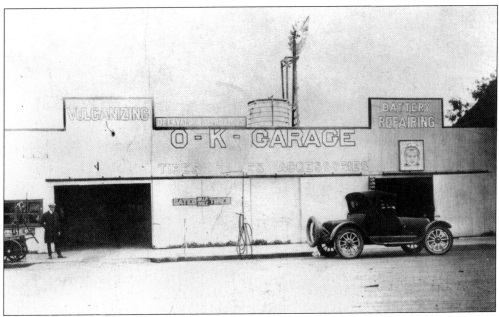

The OK Garage and Chevron Agency on Oak Street was operated by Everett LeMoin from 1930 to 1940. One of the first city fire engines was built and housed here. It had a 35-gallon chemical tank and 110 feet of one-inch hose. LeMoin later served as the third mayor of the city in 1952.

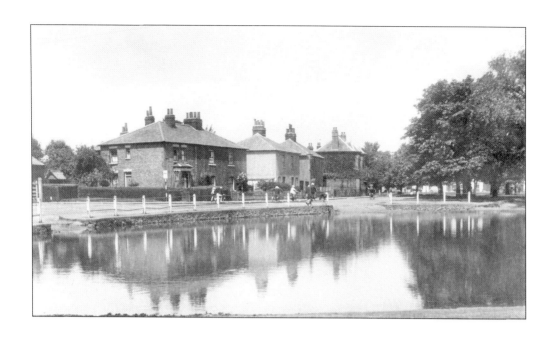

The Contra Costa County town takes its name from John Marsh's ancestral town of Brentwood, England. Brentwood is located in Essex, approximately 90 miles northeast of the city of London. Marsh's ancestors emigrated from there to Massachusetts in the 18th century. These postcard images of Brentwood, England, are from 1910. It is easy to see the dreams of what Brentwood, California, could one day become in the eyes of its 1870s-era citizens. (Courtesy of Mick Farrell Collectables, Ipswich, Suffolk, England.)

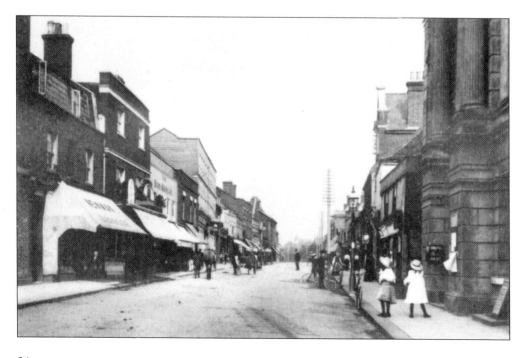

Two

First Settlers and Agriculture
Wheat and Barley for Guinness

The frontier of California fur trapping and gold mining was a man's world. Jedediah Smith and Capt. Joseph R. Walker trapped the delta as their private hunting preserve, but they did not stay. What made the first overland mule-train arrival in California a true emigrant migration was the arrival of a man, his wife, and a child in their arms. John Kelsey, Mary Kelsey, and their baby daughter arrived with the Bidwell and Bartelson party at John Marsh's behest in 1842. The settlers drawn to California prior to 1849 came to stay. True community and family life on the land in California began here in Brentwood.

John Marsh himself is credited with introducing wheat farming, cattle ranching, viticulture, orchards, pig farming, and dairies to the Central Valley. His 6,000 head of cattle was the largest herd in California in 1842 and was supplemented by 500 swine. Native American vaqueros released from the secularized missions handled ranching chores, and the women handled domestic farm life.

Marsh somewhat begrudgingly allowed a series of caretakers to live at Marsh Landing, near present-day Antioch, to maintain the produce-shipping landing. Iron House Landing, established in the 1860s, was the second shipping point and lasted 10 years. Other settlers operated shipment docks at Babbe's Landing on present-day Dutch Slough and Point of Timber along Indian Slough for transshipment where the waterway joins the San Joaquin River. Families from the East Coast living on Marsh's property as field hands or sharecroppers were continuously carving out dairy operations, farming operations, and orchards for themselves from Marsh's original 11-league Mexican land claim. Abigail Marsh commented that she was relieved to finally have neighbors close by (within two to three miles) with whom to visit. With less than a dozen families in eastern Contra Costa County prior to 1850, it could be a lonely life.

This was about to change. The volume of wheat flowing from the upper San Joaquin Valley and what would become eastern Contra Costa County soon overwhelmed water transport. To handle the shipping demand, construction of the San Pablo and Tulare Railroad began for purposes of moving grain by rail from Bethany, through Brentwood, and on to ships located along deepwater docks at Antioch and Port Costa. Here grain was warehoused for transshipment to Europe, some of it destined for Dublin, Ireland, and the brewing of Guinness beer. By 1890, Brentwood was the largest shipping point for wheat and barley west of New Orleans.

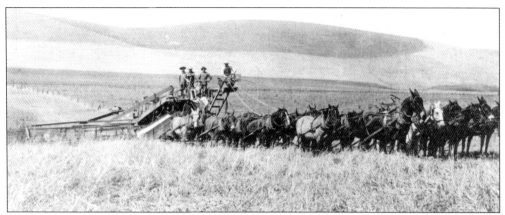

Wheat production is at the heart of upper San Joaquin agriculture industry. This Lynch harvester is drawn by 20 mules harnessed 5 abreast on the Smith ranch, near Deer Valley and Balfour Road. The harvester could travel the width of a full section of land (one mile) or more before turning around for another pass.

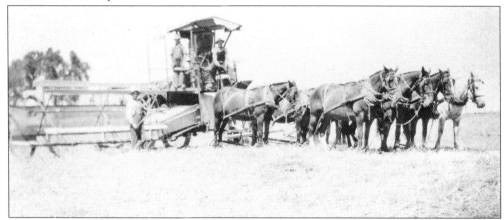

A few men—Charlie Frey, Millard Diffin, and R. E. Fletcher—a mechanical harvester, and a team of horses (above) were all that was required to harvest 640 acres in less than a week. Barley was soon added to the dry-farming mix of grains grown in the lower delta. Below, R. E. Fletcher stands on his harvest of barley in 1926. The grain was harvested, threshed, and sacked in burlap bags rather than baled like hay.

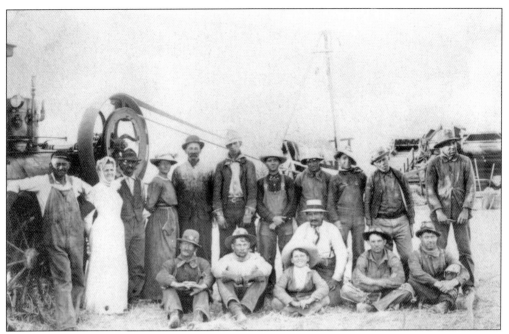

Often crews of men travelled from property to property for harvest. This threshing crew happily poses for the photographer. Myra Honegger stands second from the left, along with Clanch Jenkins, Frank Shelby, Elan Smith, and others.

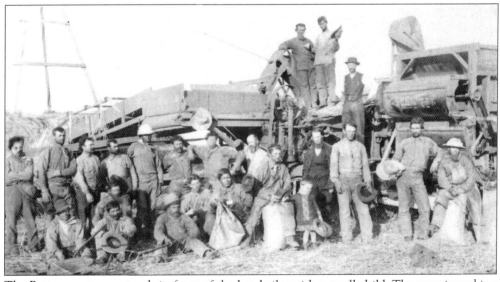

The Bettencourt crew stands in front of the hay bailer with a small child. The crew is working the rolling foothills in the Vasco region south of present-day Brentwood.

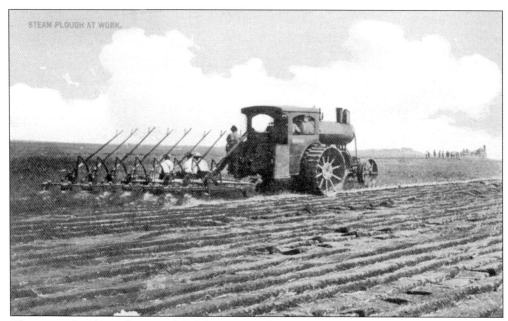

The steam plough revolutionized California agriculture. More importantly, the wide wheels kept the massive equipment from sinking into the soft soil. A sharecropping farmer commonly received three fourths of the crop revenue from farming flat lands. One fourth went to the landowner.

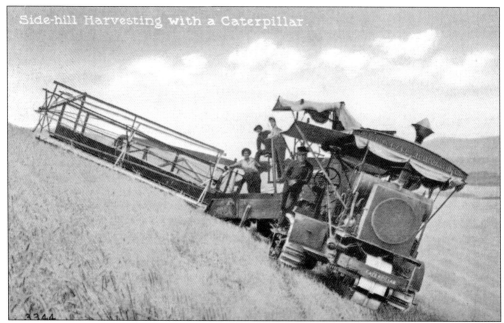

Side hill sharecropping commonly secured four fifths of the crop revenue to the sharecropper farmer, given the lower production compared to the valley floor. Oscar Starr developed this caterpillar crawler technology for the Holt Tractor Company at his Vasco research farm.

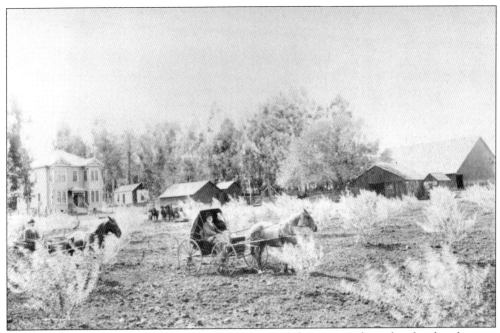

Mr. and Mrs. Andrew Smith ride in their buggy around their young almond orchard at the west end of Balfour Road. Robert Garwood Dean, the first president of the Bank of Brentwood, joins them in the other buggy. The imposing Victorian-style home was built in 1900.

Almond production was second only to commercial wheat production in Brentwood. The distinctive and fragrant almond blossom produces a soft-shell nut harvested in late summer. Blue Diamond is the marketing arm of the California Almond Board. In 2000, some 95 percent of the world's almonds were grown in California.

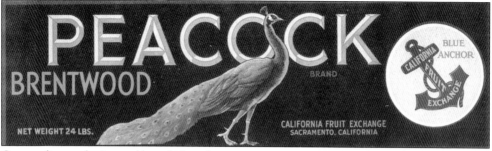

Commodity marketing and brand identification are important aspects of agricultural production. The California Fruit Exchange, marketing as Blue Anchor, was an early fruit growers' cooperative lasting 99 years in business. The group packed and shipped a wide range of fruit and vegetables from the Brentwood fields until disbanding in 2000. This colorful peacock crate image is exemplary in its color and eye-catching appeal. The label features gold lettering on a navy blue background with a multicolored, purple-and-green peacock.

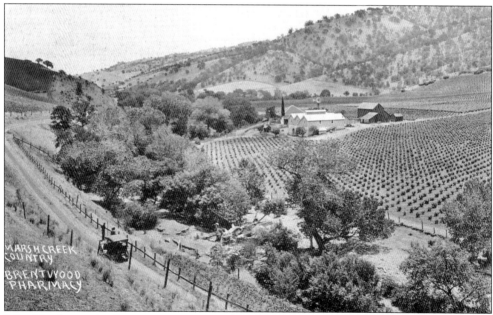

John Marsh was the first to grow grapes and experiment with viticulture. The first vines were planted behind and around his adobe, where they could be tended and protected from marauding grape snatchers. The DeMartini family expanded on Marsh's experiment with successful vineyards along Marsh Creek Road, southwest of Brentwood.

John B. Vertu and his wife hull almonds through the laborious and tiresome manual method. Later mechanical hullers replaced piecework. Hullers separated the hull from the nut and meat. Green hulls went to cattle feed. Almond meats went to marzipan.

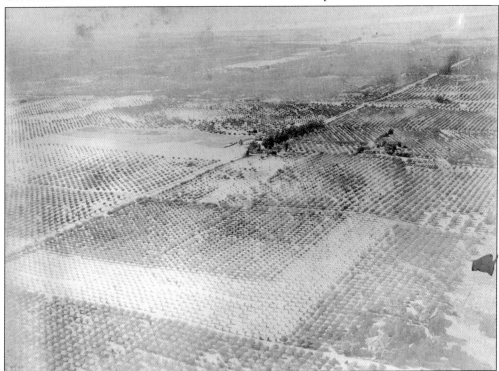

Taken in 1928, this aerial photograph of Brentwood shows how extensively orchards had been planted. Balfour, Guthrie and Company established a demonstration farm in 1910. By 1928, the area had virtually transformed from waving fields of grain to fruit orchards and row crops.

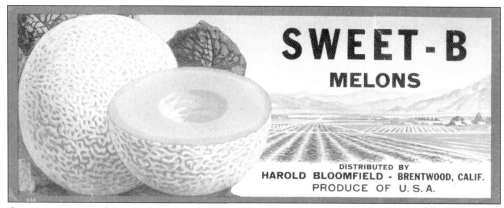

One can grow anything in the rich, alluvial soil of the delta. These packing crate labels proclaim the quality and flavor of fruit grown in the loamy soil. The melon label suggests furrows and fields as far as the eye can see. This does not exaggerate the scale of farming.

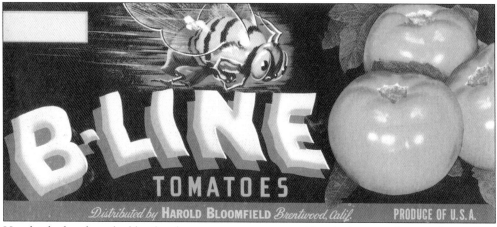

Handpicked and -packed beefsteak tomatoes are now considered a heritage fruit in the modern days of mechanical harvesting. The message conveyed by the crate label is that these tomatoes are so sweet that a honeybee can mistake them for nectar. People should also make a beeline and enjoy these delicious red beauties.

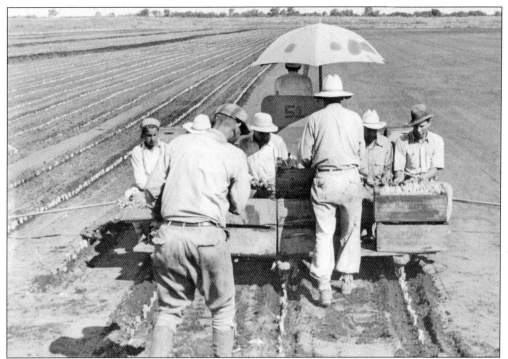

These men are planting asparagus. The vegetable thrives in soft peat soil and lots of fresh water. The delta, which provides plenty of both needs, is the center of asparagus farming in California. Creeping salt incursion into irrigation water threatens production, however.

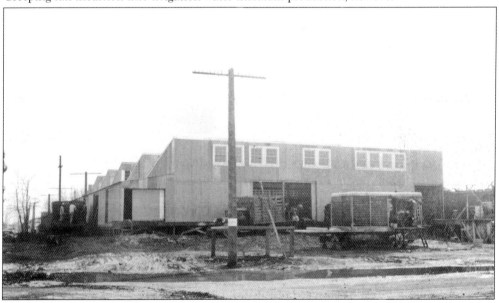

This Balfour, Guthrie and Company packing shed was located on the north end of town, where the Safeway shopping center is today. It was acquired by the H. P. Garin Company, which owned a second packing shed at the current site of the Lion's Club on Walnut Boulevard. The H. P. Garin Company, originally of Hayward, picked, packed, and shipped from Brentwood beginning in 1923. Garin purchased 600 acres and leased 600 more acres in 1929.

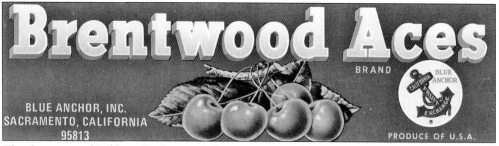

The departure of Balfour, Guthrie and Company opened opportunities for other agribusiness concerns. The Blue Anchor cooperative packed and shipped throughout the state. Brentwood bing cherries were great summer favorites.

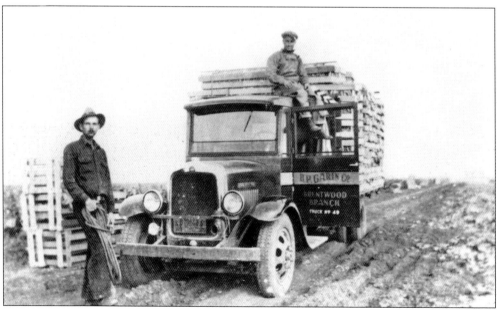

An H. P. Garin truck readies to transport lettuce to market. The company had expanded its landholdings to 7,000 acres in orchards and vegetable produce by 1935. Garin's fields in Brentwood specialized in lettuce, cabbage, peppers, peas, tomatoes, and other vegetables.

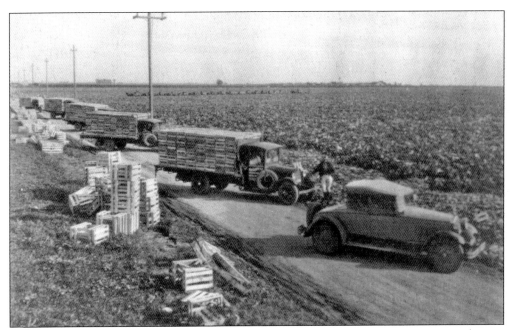

By 1935, the Garin Company had replaced Brentwood Irrigated Farms as the community's biggest employer, with 1,200 to 2,000 seasonal employees. Trucks rolled ceaselessly during the summer harvest months. The cabbage fields were located along Payne Avenue southwest of town.

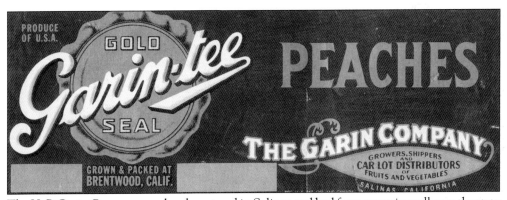

The H. P. Garin Company was headquartered in Salinas and had farm operations all over the state exceeding 30,000 acres. However, its peaches were grown, packed, and shipped from Brentwood in refrigerated railcars. Fresh peaches arrived in New York City three days later.

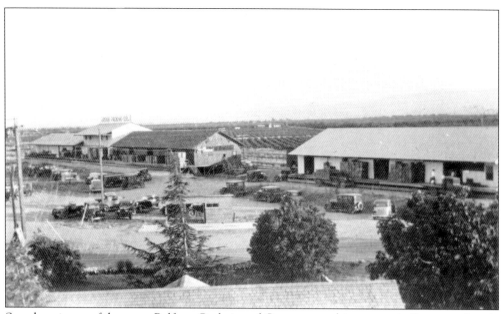

Seen here is one of the seven Balfour, Guthrie and Company packing camps in Brentwood, aptly named the Marsh Packing Shed. Each camp specialized in a particular line of crops, orchard fruit, grain, or animal husbandry. Each had its own labor bungalows, water, sanitation, and employee luncheon facilities.

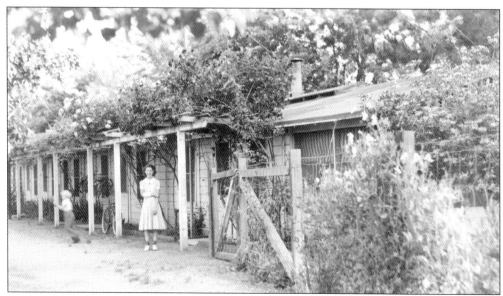

A woman poses in front of a labor camp bungalow provided by Balfour, Guthrie and Company near its packing sheds. Each bungalow included one bedroom and a kitchen. This image was taken on May 12, 1938.

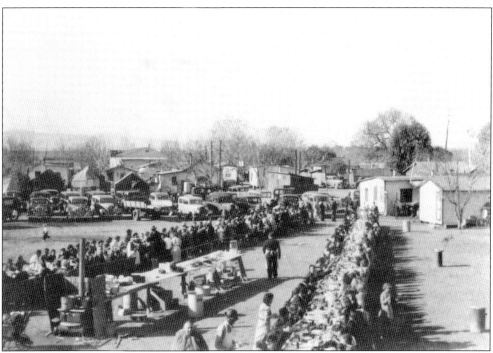

O. R. Davis, the owner of a migrant worker camp along State Highway 4 at Delta Road, staged this and many other barbecues in 1935 for members of the Davis Auto Camp, sometimes feeding as many as 1,000 people. Note the long tables and number of diners.

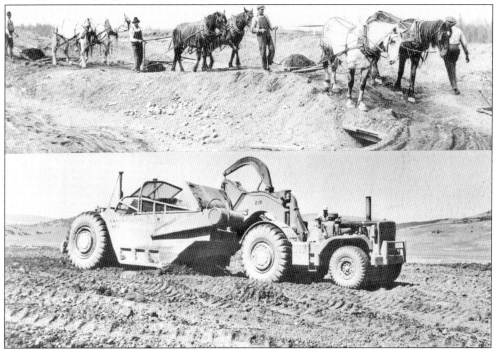

This style of earthmoving, employed at Brentwood's orchards, contrasts with the soil conservation grading methods of today.

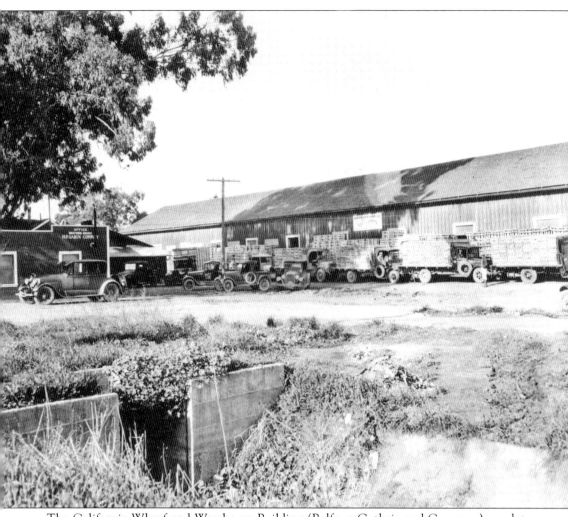

The California Wharf and Warehouse Building (Balfour, Guthrie and Company) was later occupied by H. P. Garin Packing in the 1930s. The building was located along the Southern Pacific Railroad line near the intersection of Fairview Avenue and Lone Tree Way near present-day Oak Valley Nursery. Balfour, Guthrie and Company dotted the San Pablo and Tulare Railroad, later the Southern Pacific Railroad, with grain collection warehouses such as this one. Grain from these warehouses flowed to their main warehouse and pier at Port Costa for final loading onboard ship to Britain.

In 1932, the *Byron Times* declared potatoes, tomatoes, asparagus, corn, celery, and apricots the "Delta Monarchs" of agriculture. Harry Hammon, editor of the *Byron Times*, also described his newspaper as the "Monarch of the Weeklies." In this manner, Hammon emulated his previous employer, the *San Francisco Sun*, in its claim to be the "Monarch of the Dailies."

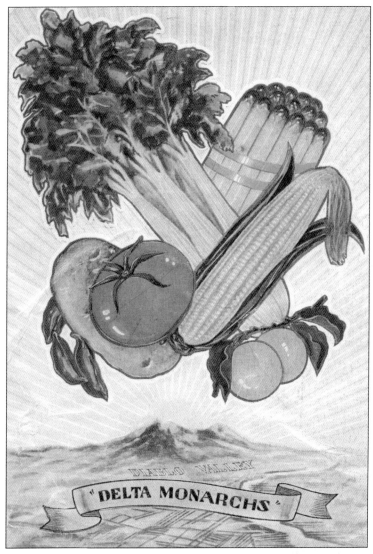

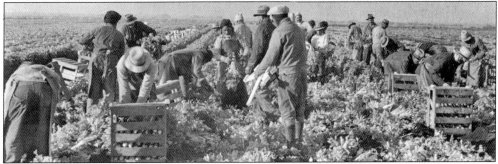

Farm workers pick and pack celery. Brentwood and the delta were the major growing areas for celery and sugar beets until saltwater crept up the delta and into the irrigation system. Both crops require large quantities of fresh water and do not tolerate saltwater incursion as well as other produce.

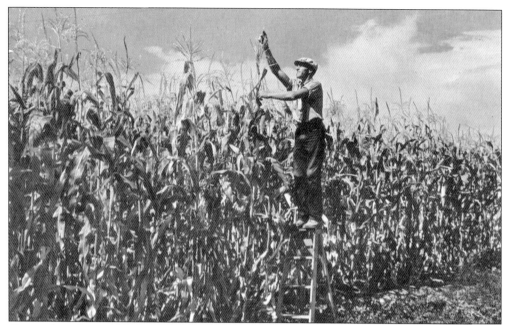

Corn is king. Just add water and one gets eight-foot-tall stalks of corn. Brentwood sweet corn is justly famous and available from June to September. Fields often produce two or more crops per growing season.

Men prepare a chemical fungicide with water taken from a creek in anticipation of spray application in pre-EPA-era Brentwood. They do not wear rubber gloves or respirators. How times have changed.

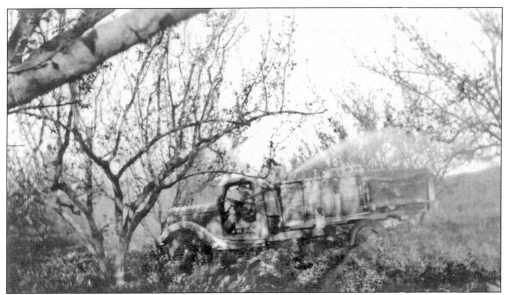

Spraying dormant apricot trees with a fungicide in February is no easy matter. Wet and muddy fields could make it impossible to apply product by miring the truck up to the axle in mud. Aerial crop dusting, pioneered by Brentwood Irrigated Farms and Charlie Weeks Sr., would change the way pesticide was applied.

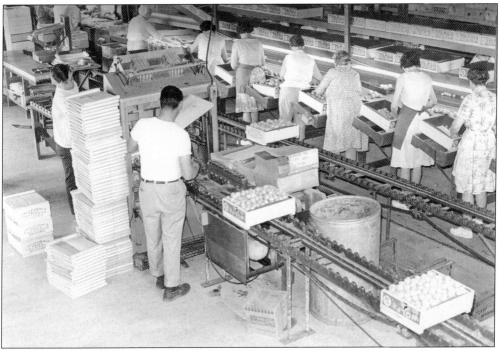

Apricots were hand picked, hand sorted, and hand packed upside down in paper-lined, custom-sized Brentwood Lug wooden crates. The handmade crates were packed to overfilling, the lid mechanically attached, and the boxes righted for shipment. The apricots were then shipped in iced railroad cars to Boston and New York for the carriage trade. They arrived in three days in beautiful condition.

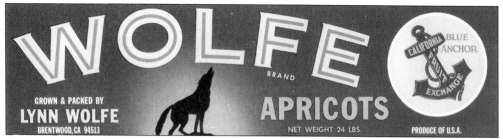

The Wolfe brand wooden crate label featured a distinctive blue and gold color scheme and a black howling wolf. Local farmer Lyn Wolfe had this label designed and illustrated by *San Francisco Examiner* political cartoon artist Ken Alexander.

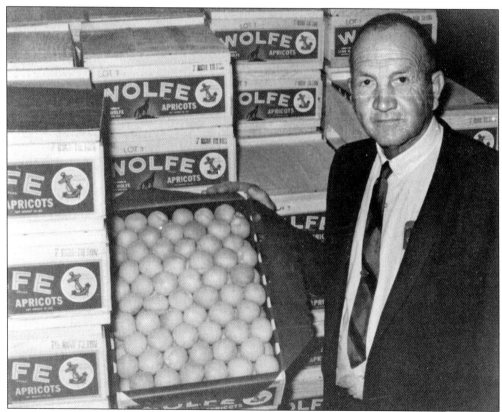

In New York, Lyn Wolfe displays produce in his invention, the Brentwood-size lug box. Each fancy-grade apricot was hand placed in a Brentwood Lug wooden fruit crate so named for its size, just slightly smaller than a Los Angeles–size lug to hold two rows of fancy-grade Tilton apricots.

Three

BALFOUR, GUTHRIE AND COMPANY
THE BEST IN THE WEST

Robert Balfour, 25, and Alexander Guthrie, 24, arrived in California from Liverpool, England, in 1869. The partners engaged at once in the finance, insurance, and investment opportunities that characterized the speculative boom of Victorian San Francisco. The Big Bonanza was underway in Virginia City; Lucky Baldwin was president of the new Pacific Stock Exchange; James Fair was making millions of dollars; and the transcontinental railroad was complete. The two young men planned to ride the speculative boom to great success. Home in Liverpool, the senior Balfour Williamson firm members and the third Balfour, Guthrie and Company partner, Robert Forman, remained to coordinate business in England.

Their speculation interests evolved into agricultural commodity brokering. The vast tracts of dry wheat and barley farming in the upper San Joaquin Valley and eastern Contra Costa County produced grain far in excess of California consumption. Balfour and Guthrie began brokering grain and soon purchased product outright. In 1882, they established a grain warehouse and wharf at Port Costa for shipments via sailing vessels bound for Britain. Grain warehouses soon followed in Brentwood and Byron along the new San Pablo and Tulare Railroad line. By 1900, Balfour, Guthrie and Company was the largest grain buyer in the world, and Brentwood and the upper San Joaquin Valley formed the largest wheat-producing area in the county.

Balfour, Guthrie and Company began purchasing the Marsh Grant property from foreclosure and civil litigants. The firm began in 1900 to acquire the financial interests of the Savings and Loan Society of San Francisco, Messer's Bergin, and James T. Sanford's heir for a price variously reported from $200,000 to $650,000. The company's aggregate property purchases of approximately 12,616 acres by 1910 essentially restored the boundaries of Rancho Los Meganos. The Town of Brentwood received the financial benefit of the land speculation. The agents for Balfour, Guthrie and Company were responsible for creating the town's infrastructure, including domestic water and sewer systems, paved streets, telephone service, irrigation canals, and pumping stations. They improved upon their investment by underwriting the Bank of Brentwood. A two-story superintendent's home was built in a park-like setting designed by Golden Gate Park landscape gardener John Hays McClaren (1846–1943). The beautiful Brentwood Hotel, built in 1913 at a cost exceeding $40,000, fed, wined, and lodged potential investors with accommodations to rival any in the Greater San Francisco Bay Area. Anything and everything was done to make the Brentwood area attractive in order to sell the subdivided Los Meganos land tract to potential buyers. From the start, Balfour, Guthrie and Company planned a return on investment based on real estate speculation, not farm operations.

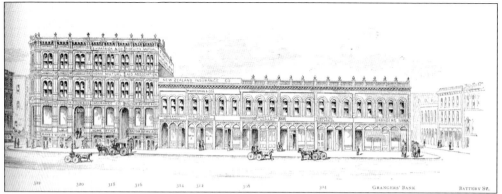

The Balfour, Guthrie and Company office was located at 316 California Street in San Francisco, as listed in the *1895 Illustrated Directory of the San Francisco Business District*. The firm had been established in San Francisco for over 25 years and, at the time of this elevation drawing, was the largest exporter of grain in the country.

After the 1906 earthquake and fire destroyed the office building and all its business records, Balfour, Guthrie and Company moved slightly west to 350 California Street. This image of the headquarters was taken in the 1920s. The First Interstate Bank Building now stands in its place.

Balfour, Guthrie and Company holdings, also known as Brentwood Irrigated Farms after 1910, were vast and encompassed nearly all of Marsh's original Rancho Los Meganos. The firm quietly purchased virtually all of the contested, litigated, and separately held properties of the Brentwood Coal Company, Charles and Alice Marsh, James Sanford, and others to reconstitute the Marsh Grant by 1910.

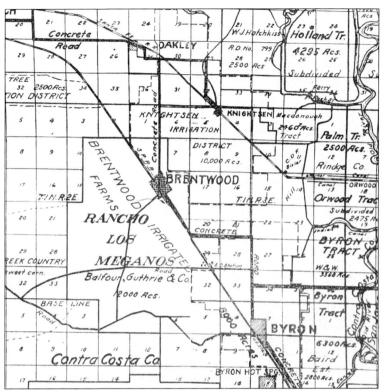

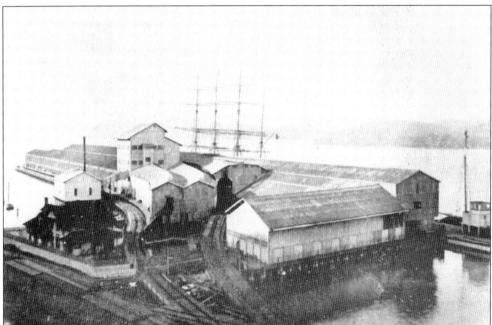

The secret to Balfour, Guthrie and Company's success was this wharf and the string of warehouses supplying it along the San Pablo and Tulare Railroad, beginning at Bethany and extending to Port Costa. The California Wharf and Warehouse was the point from which all the grain and produce from the Brentwood area was shipped.

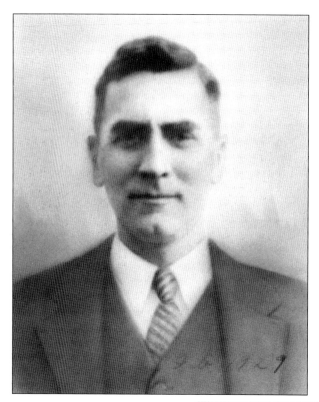

The third Balfour, Guthrie and Company superintendent was Scotsman Alexander Duncan MacKenzie (1883–1928). Born in Edinburgh, MacKenzie, his wife Beth, and three children were brought to Brentwood from the Imperial Valley in 1922. He was an experienced company man and held responsibility as the agent for all of Balfour, Guthrie and Company's California holdings. His election to the Balfour, Guthrie and Company board of directors was imminent when he died unexpectedly in 1928.

Alexander MacKenzie stands with his eldest daughter, Helen (left), age 14, and his youngest son, John (right), age 6. Missing from this image and perhaps taking the photograph is the middle child, Mary. They initially took quarters in the Brentwood Hotel. Family legend states that MacKenzie declined to live in Marsh's Stone House, as he wished to be able to walk home for lunch; the Stone House was inconveniently too far out of town.

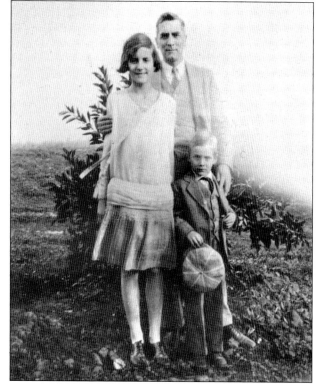

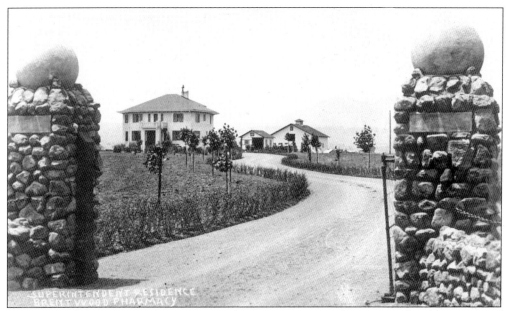

MacKenzie did move into the superintendent's two-story residence near the intersection of Balfour Street and Walnut Boulevard, but not for long. He soon sold it, saying that he had been hired to make money, not to spend it. He was to deal with the irrigation canal construction delays and sell farmland. The planting of orchards was designed to make land more attractive to potential buyers.

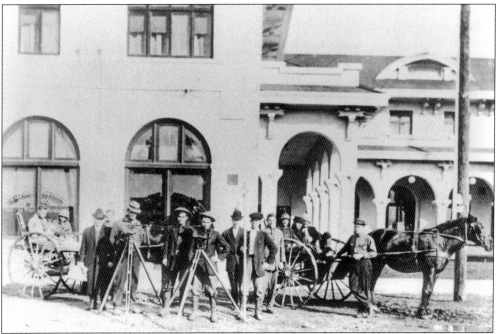

This team of professional surveyors, posing in front of the Brentwood Hotel around 1914, was only the advance guard of Balfour, Guthrie and Company property plans. Board secretary Robert McLeod and superintendent Alexander Buress were charged with subdividing, marketing, and selling farm property. The key to land sales was infrastructure improvement.

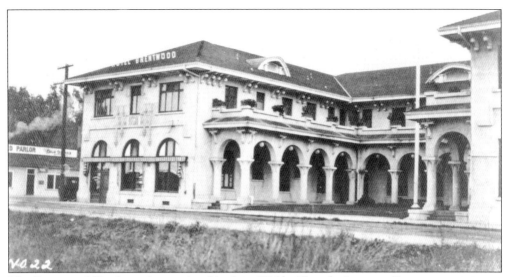

The Brentwood Hotel was designed and built in 1914 by Hercules Logan, a Scotsman arriving in San Francisco in 1904. Logan had designed buildings on Angel Island and would also design the Bank of Brentwood and the supervisor's residence. The Brentwood Hotel was razed and replaced by a Chevron gas station in 1967.

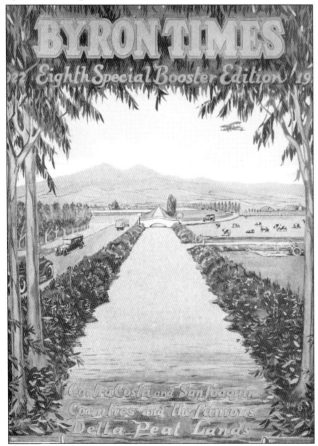

Water was key to diversifying agricultural production and selling land. The *Byron Times* development edition of 1923 featured the miles of concrete-lined canals created to bring water 10 miles from Indian Slough. This gave true marketing meaning to the renaming of Balfour, Guthrie and Company's property as Brentwood Irrigated Farms.

Balfour, Guthrie and Company's experimental farm and orchard were great successes. Orchards replaced grain on the valley floor as irrigation became available. Concurrent with MacKenzie's arrival, the firm began orchard planting in an effort to boost operational profits on remaining lands.

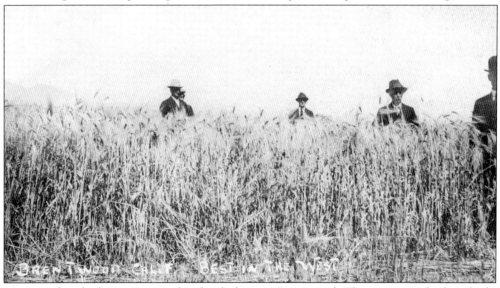

Men stand and admire ripening heads of wheat in Brentwood. The grain stands chest high, full, and heavy. No wonder Guinness beer tastes so good. The company's marketing slogan, "Best in the West," has been taken as the club name for the local business booster and social improvement organization.

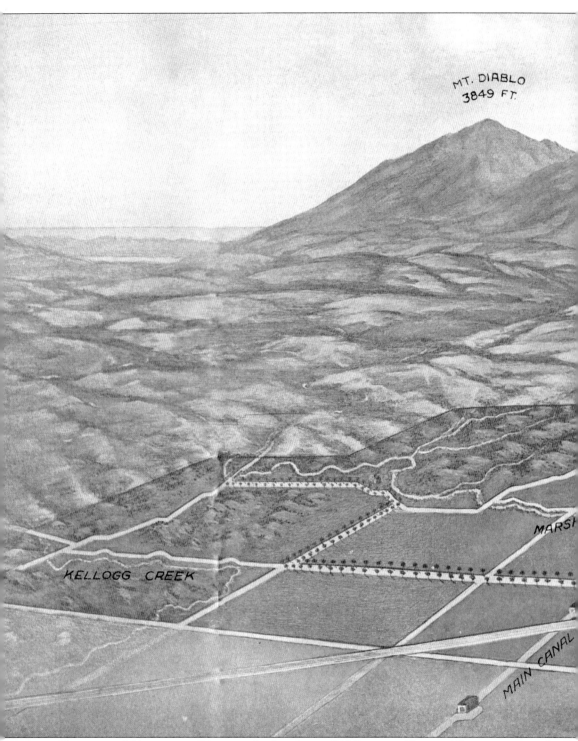

MT. DIABLO
3849 FT.

MARSH

KELLOGG CREEK

MAIN CANAL

This interior foldout image of Brentwood, taken from a 1930 Brentwood Irrigated Farms promotional brochure, emphasizes how rural the area continued to be. The city of Brentwood can be measured in less than 10 square blocks. The enormity of the Brentwood Irrigated Farms property is graphically

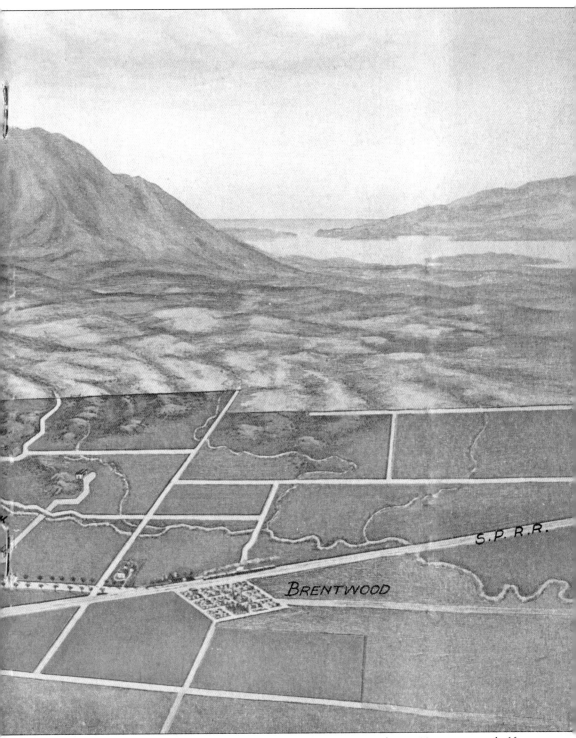

shown in the dark highlighted area. The property encompasses almost 19 sections or half a township on a government survey map.

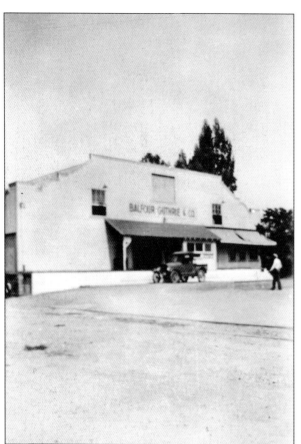

The Brentwood field office for Balfour, Guthrie and Company was situated in this modest building next to the railroad tracks. The office originally occupied the first floor of the Brentwood Hotel but moved to this location in the 1920s. The building still stands at the foot of Oak Street.

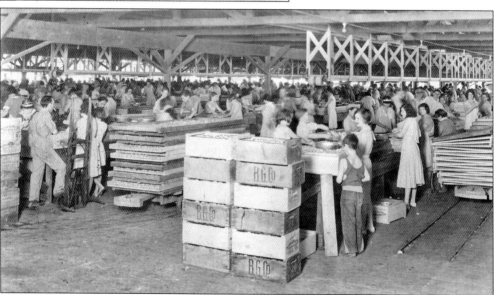

The Balfour, Guthrie and Company packing shed was a huge operation, employing hundreds of seasonal packers during the summer fruit harvest. These individuals are cutting apricots in half, discarding the pit, and laying the halves individually onto drying trays.

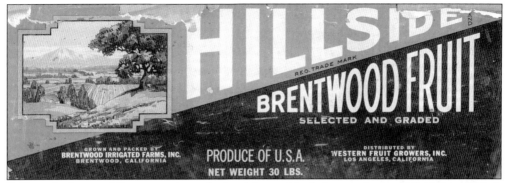

Balfour, Guthrie and Company also picked and shipped fresh fruit under the Hillside brand label. Refrigerated railcars insulated and packed with ice ensured fresh produce in New York City within three days of departure from Brentwood. The employees packed and shipped 1,996 tons of fresh fruit to the East Coast in 20 days in 1937.

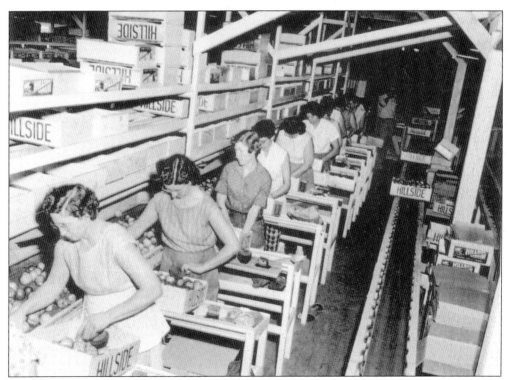

Women hand select and pack peaches into Los Angeles–size wooden lug boxes in the 1940s. Selecting and packing the fruit into boxes was generally women's work. Men were found most often in the fields or running mechanical equipment.

With an operation the size of Balfour, Guthrie and Company, it is not surprising that the firm was a focus of labor unrest in the 1930s. Wages were 34¢ an hour as commodity prices dropped during the worldwide Depression. The first agricultural strikes in California were held in Brentwood years before the United Farm Workers movement popularized by Caesar Chavez in 1962.

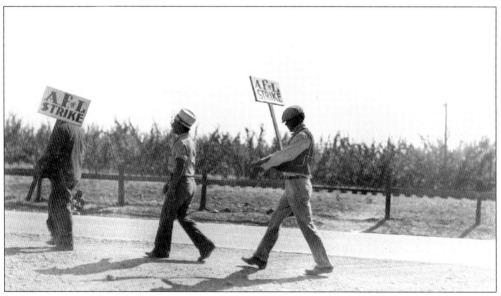

Strikers carrying American Federation of Labor affiliation on strike signs walk the picket line along the railroad tracks outside the Brentwood Irrigated Farms field office in 1931. Labor unrest continued, and the threatened general strike of 1934 endangered harvesting the crop. Some 10,000 people arrived for seasonal work but did not all find employment.

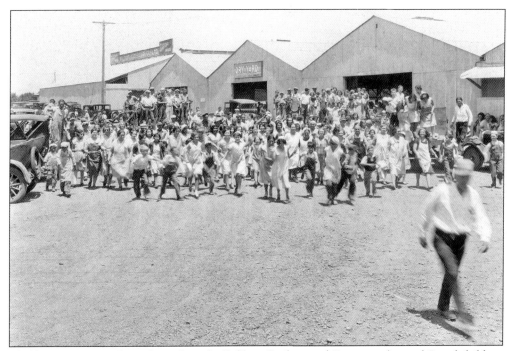

Children, women, and men burst from the Balfour, Guthrie and Company dry yard. Local children and transient families found summer employment in the packing sheds. Apricot cutting continued as local schoolchildren's summer employment until 1985, when dried-fruit market prices no longer made it profitable for the farmer.

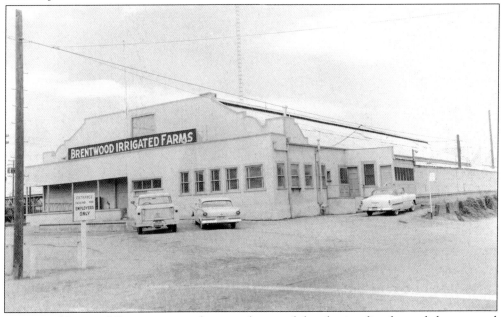

Brentwood Irrigated Farms continued as a packing and distribution firm beyond the eventual sale of the original 1,200 acres to individuals in subdivided 20-to-40-acre parcels. Packing and shipping operations persisted until 1943, when the company sold its last 2,300-acre land parcel, equipment, improvements, and the crop to Tom Peppers of Mentone.

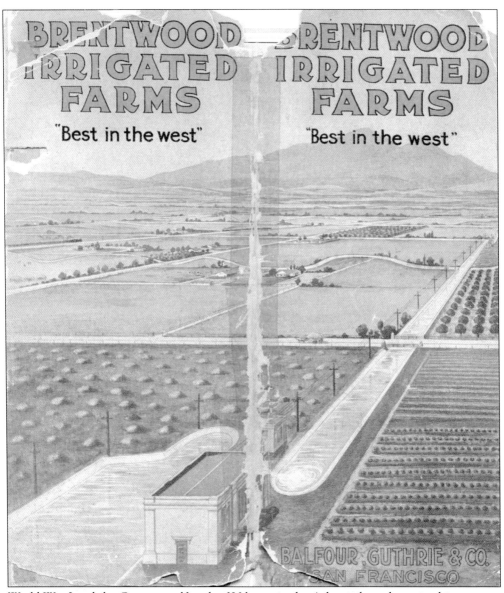

World War I and the German wolf pack of U-boats in the Atlantic brought grain shipments to Britain almost to a halt. England was down to its last six weeks of food stocks just as the United States entered the war and a system of convoying supply ships was devised. Cash flow was tight. Real estate subdivision and land sale marketing was increased to ensure Balfour, Guthrie and Company's survival.

BRENTWOOD IRRIGATED FARMS

Late in the 1920s, a new packing shed was built for the shipment of fruits and vegetables to eastern markets. The orchards MacKenzie planted, which increased operating profits while also increasing land sales potential, were coming into maturity. The staples shipped in these wooden crates included apricots, peaches, tomatoes, and melons.

Upon the premature death of John MacKenzie in 1929, Charles Weeks Sr. was promoted to supervisor of Balfour, Guthrie and Company operations in Brentwood. He was the first non-Scotsman employed by the firm and its last superintendent. The Nebraska-born Weeks innovated agricultural technology, encouraging invention and mechanization whenever possible.

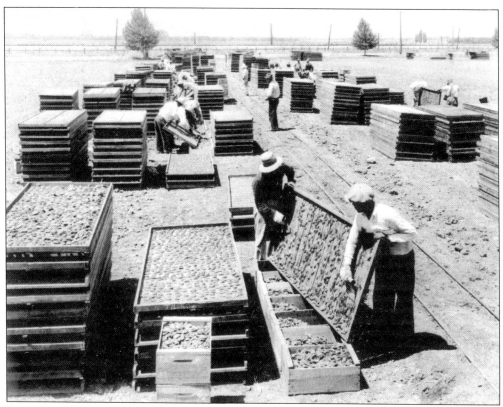

Apricots and peaches, cut in halves and dried in the sun, are laid out on drying racks by the acre. The drying yard and dehydration facility was the largest in the world and included sulfur houses, railroad transport from the cutting shed to yards, living quarters, and a luncheon area for laborers.

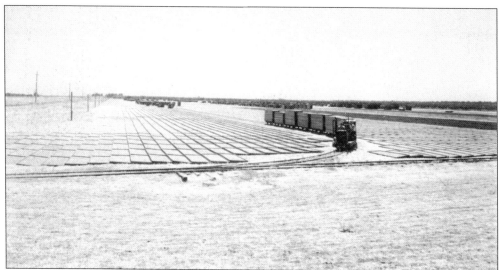

A small narrow-gauge railroad was constructed to move the vast drying racks of fruit from the cutting shed to the drying fields. About 600 individuals were employed to cut the fruit, and as many as 30,000 five-by-eight-foot trays of fruit were spread out in the sun at any one time.

A favorite of families was Contra Costa County Health Department nurse Frances Mackenzie (right), Public Health Nurse, shown here holding an infant. She delivered babies and offered health care to all employees of the firm living in labor bungalow housing.

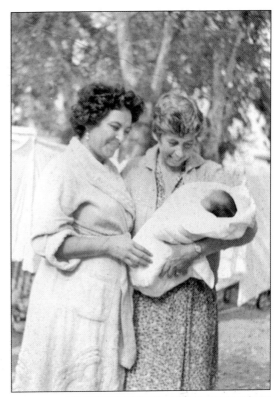

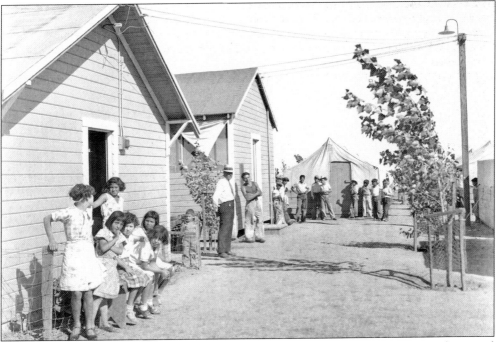

Children and families pose in front of the 50 bungalows provided for the transient and seasonal laborers working at the seven Balfour, Guthrie and Company production yards in Brentwood. This camp was located where the Brentwood police station is today.

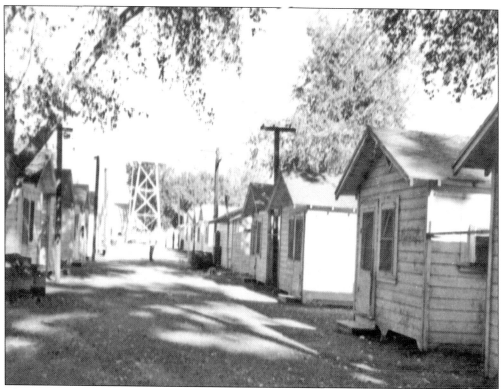

These cabins, consisting of one bedroom and a kitchen, are typical of the housing provided for transient labor in the 1930s and 1940s. Many Oklahoma and Arkansas families were drawn here by the promise of employment during the Great Depression and decided to stay.

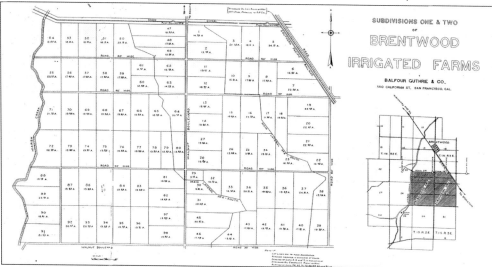

Small parcels of 10 to 30 acres could be purchased at reasonable prices directly from Balfour, Guthrie and Company. The firm received cash for the land; the buyer got a farm and a livelihood; and Balfour, Guthrie and Company still shipped and packed. The burden of farming transferred to the farmer, and the company went back to what it always did best: commodity buying, brokering, and speculating.

Four

EDUCATION
AND WORSHIP
HAIL LIBERTY

The Brentwood community is created by families, which is evident in its early establishment of schools. John Marsh had not been dead 10 years when Liberty School was established in 1865. The Civil War had just ended, and liberty must have been foremost on people's minds when naming this first civic building. Erecting this one-room schoolhouse, which doubled as a community center, anticipated the founding of Brentwood township. The grammar school was located on Marsh Creek Road, coincidentally just beyond the Rancho Los Meganos boundaries.

The people of Deer Valley were not to be outdone and so built a one-room schoolhouse on the farm of W. C. Haney at what is today the southwest corner of Balfour and Deer Valley Roads. Four schoolhouses were established in the area, the last of which was torn down in 1920. Eventually, the Liberty School and Deer Valley School merged into the Brentwood–Deer Valley School District in 1918. In 1867, Lone Tree School was established west of Brentwood en route to Antioch. It was located just north of the west end of present-day Sand Creek Road. Students continued grammar school in this two-room schoolhouse until fall 1959. It then merged into the newly renamed Brentwood Union School District.

The first school built inside Brentwood township dates to 1879, well after the establishment of a general mercantile, a blacksmith, and several saloons. The school was located opposite the present-day Methodist church. The familiar Brentwood Elementary, standing across from present-day Liberty High School, was built in 1923–1924 and expanded in the 1930s to accommodate children from the Dust Bowl whose families followed the crops.

By 1900, Brentwood showed all the evidence of a traditional Protestant American small town. Reading, writing, and arithmetic were taught in five local grammar schools. Two churches were built: the Methodist Episcopal church in 1885 and the Christian church in 1889. In 1949, as cultural demographics were changing, the Immaculate Heart of Mary Catholic Church was constructed. On Easter Sunday, March 28, 1948, Brentwood's church of Latter Day Saints was made a branch of the Pittsburg, California, ward. It became an independent branch the following year.

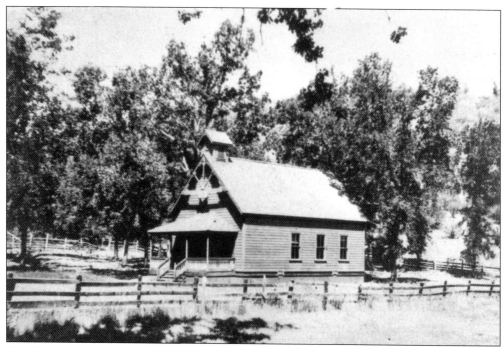

The first educational institution in the Brentwood area was Liberty School, erected in 1865. It was located on Marsh Creek Road on the perimeter of Rancho Los Meganos. This one-room schoolhouse continued as an independent school until 1944, when it merged with the one grammar school in Brentwood to form the Brentwood Union School District.

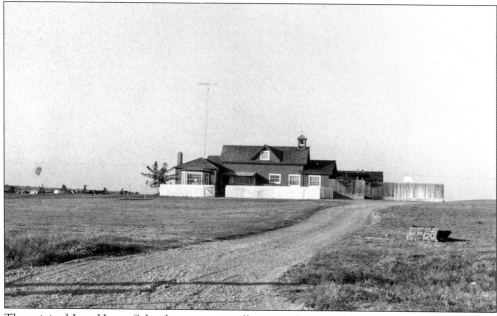

The original Iron House School was strategically situated near Babbe's Landing, one of the first commercial shipping centers in eastern Contra Costa County. Pioneer Sarah C. Abbott Sellers applied for state district status for the school in 1862 and served as the first woman school trustee in California.

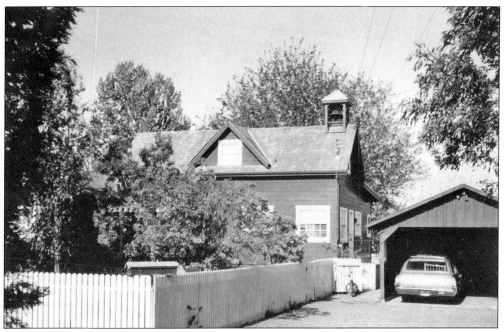

When the Iron House School closed its doors, the building was not torn down; it was moved and recycled into a residence. Note the recognizable school bell tower still on the roof. The building stands on present-day Brentwood Boulevard near Dainty Avenue.

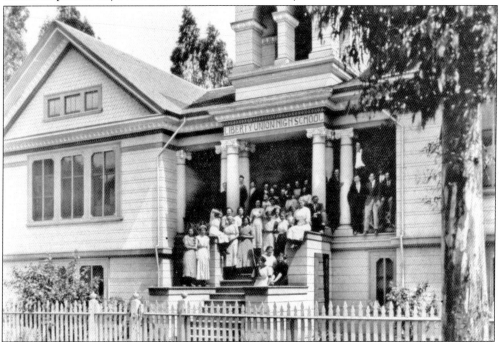

The original Liberty Union High School building opened in 1908. Prior to its construction, the few high school students were taught in the back room of the grammar school. The wood-frame building burned down in 1918 as the result of a fire started in the students' chemistry laboratory. The school was situated at the site of the present Veterans' Hall.

The first Liberty Union High School graduate was Edith A. Sellers (1887–1968) in 1905. She was the daughter of George and Addie Buckley Sellers. Educated at Line Oak School and Liberty High School, she attended the University of the Pacific, Stockton, where she studied music and business. She and her husband, Herbert French, resided in San Francisco.

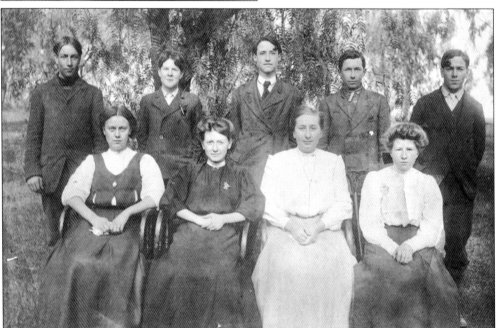

The graduating class of 1907 included many names that would figure prominently in Brentwood over the next 40 years. Pictured from left to right are the following: (first row) Bessie Collins Strachow, Edna Heck Crowther, Iva Bonnickson Dickson, and Edna Heidorn Hill; (second row) Ray Shafer, Billy Morgan, Lester Liudinghouse, Robert Wallace, and Earl Shafer.

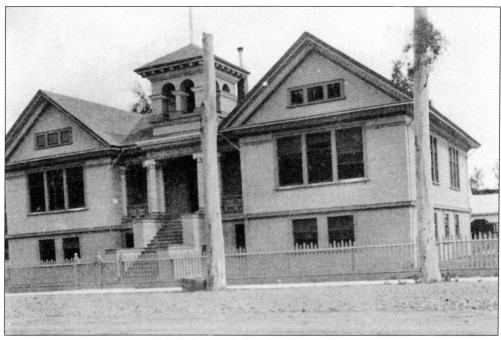

This rare real-photo postcard of Liberty High School, taken in 1908, is a unique sun print. Sun printing uses a film of gelatin spread on a flat, rigid surface that is exposed for a period of up to 30 minutes. The postcard is then produced through the conventional lithographic printing process.

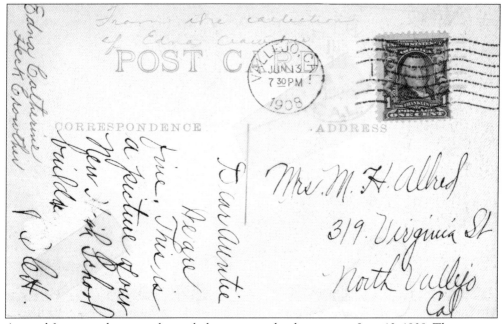

A proud former student sent this real-photo postcard to her aunt on June 13, 1908. The message reads, "Dear Auntie, We are fine. This is a picture of our new high school building. E. Heck." The card comes from the collection of 1907 graduate Edna Catherine Heck Crowther.

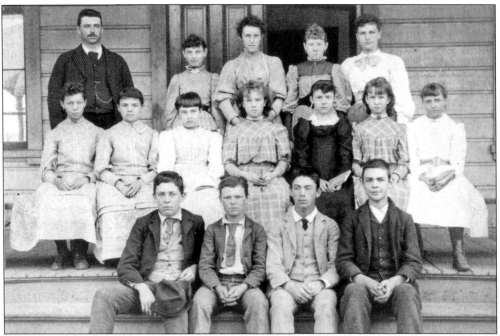

Shown here is the Brentwood Grammar School in 1895.

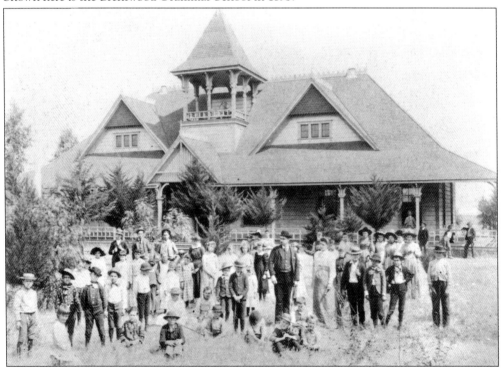

The Brentwood Grammar School was built in 1879, almost 15 years after the first school, Liberty, admitted students at Marsh Creek. In the late 1800s, it was expanded at a cost of $4,300 to include two more classrooms and remodeled in the Eastlake architectural style. It was located across from the present-day Methodist church.

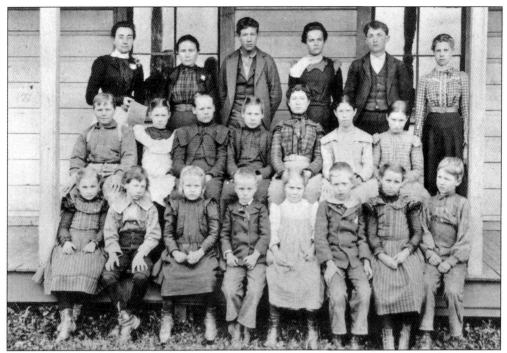

This school photograph shows the teacher and students of Deer Valley School's class of 1898.

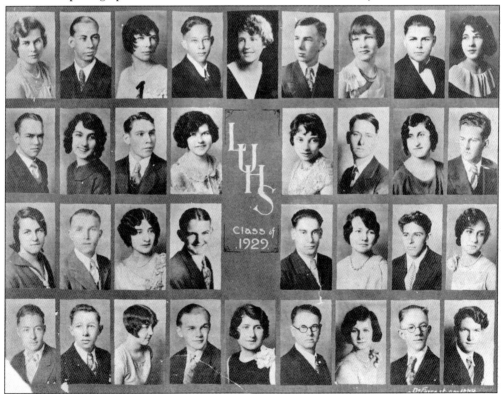

Seen here is the Liberty Union High School graduating class of 1929.

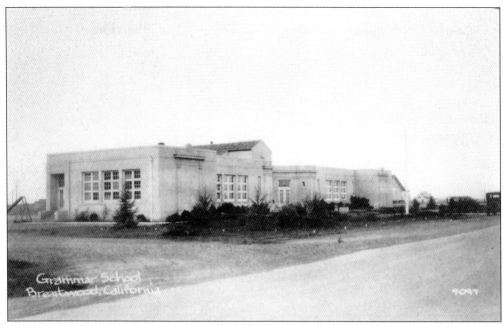

The first building of the Brentwood Elementary School, used today for community and adult education, was erected in 1923. It initially consisted of an office, auditorium, four classrooms, and a meeting room. Note the Brentwood Irrigated Farms packing shed located just north of the school building.

This Davis Photo postcard of the Brentwood Elementary School reveals the school with an extra nine classrooms added in the 1930s. The exodus from the Dust Bowl brought many new children to the district while their parents followed the seasonal crop harvest. Transient students lived close by at the various labor camps and went to school, not work.

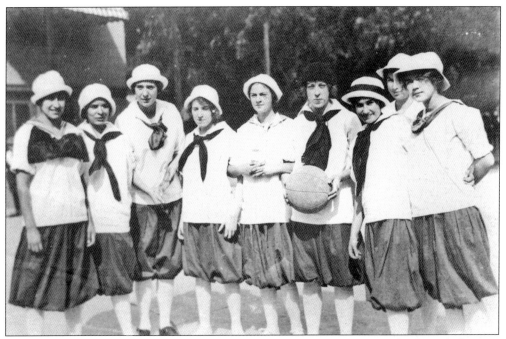

Shown here is the Liberty Union High School girls' basketball team of 1921. Note the physical education garb: sailor middy blouses, dark bloomers, white knee-high stockings, sensible shoes, wide-brim hats, and large bows tied to individualize the apparel. Then as now, accessorizing is everything.

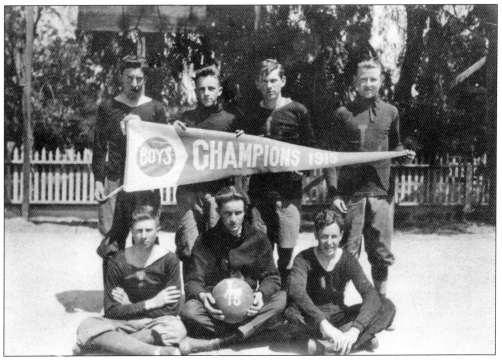

The Liberty Union High School men's basketball team were the champions of 1915.

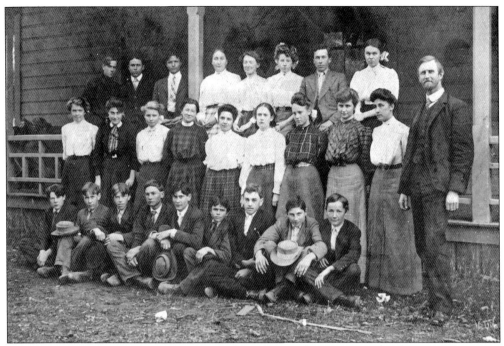

Students and their teacher pose in front of the Brentwood Grammar School in 1934.

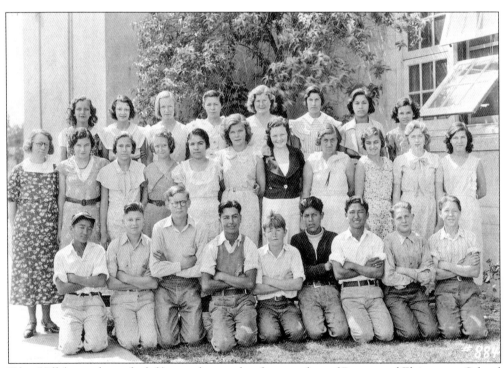

Edna Hill (second row, far left) served as teacher for attendees of Brentwood Elementary School about 1934.

Liberty Union High School had many Japanese American students enrolled as the United States entered World War II. Eight Brentwood residents attending high school found their education and life as they knew it forever changed on April 24, 1942. All individuals of Japanese descent living in east Contra Costa County were ordered to report to the I.O.O.F. Hall in Byron for evacuation via train to internment camps for the duration. These eight students and their families left the area. All had A and B averages. One was to have been class valedictorian for the June 1942 graduating class. From left to right at right are (top row) Roy Hiratsuka and Michiko Nishiura; (bottom row) Sam Okazaki and Sueo Okazaki. From left to right below are (top row) Izumi Taniguchi and George Terai; (bottom row) Toyo Yaki and Shinobu Yamamato.

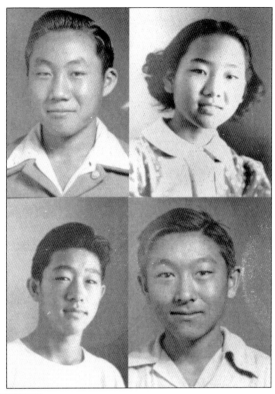

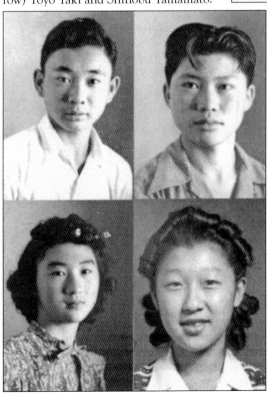

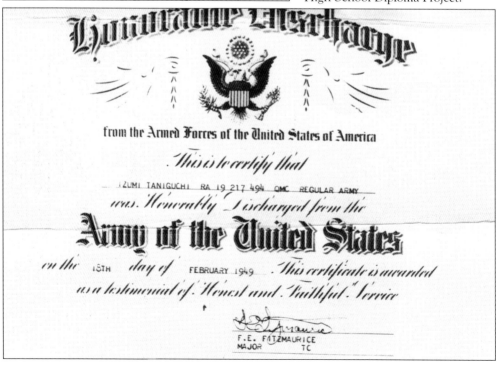

ENLISTED RECORD AND REPORT OF SEPARATION
HONORABLE DISCHARGE

Voluntary enlistment in the U.S. Army was an option for those Japanese Americans wishing to leave the internment camps. Izumi Taniguchi (pictured on page 81), a member of the Liberty Union High School class of 1943, enlisted for the duration and distinguished himself as a member of the newly created Military Intelligence Language School (MIS), established at the Presidio in San Francisco. Sergeant Taniguchi subsequently served as a Japanese language interpreter with the army of occupation stationed in Japan. After the war, he received his undergraduate, master's, and doctorate degrees in economics from the University of Texas. He received his Liberty High School diploma posthumously in 2005 as part of the California Nisei High School Diploma Project.

Established in Brentwood in 1889, the Christian church was constructed in 1905. The building later served as the Seventh Day Adventist church before being torn down in 1970. The Methodist Episcopal church is visible in the background.

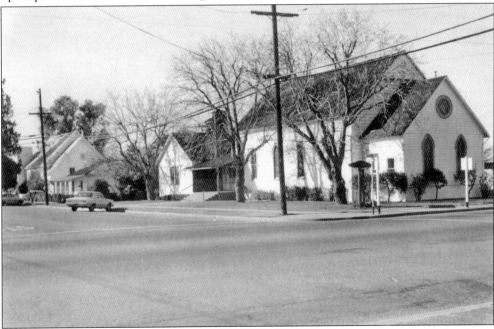

The United Methodist Episcopal church was the first house of worship in Brentwood when it was founded in 1885. It received substantial financial backing from Alex Buress, local superintendent of Balfour, Guthrie and Company, who was a strong Methodist. That financial support continued under supervisor Alexander MacKenzie, although he was not a member of that faith.

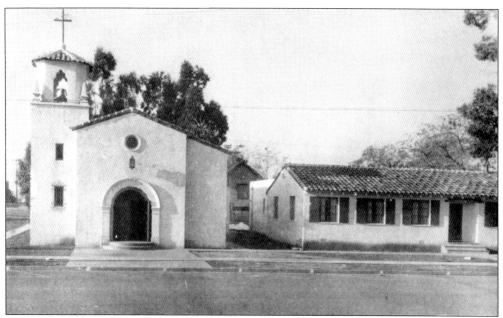

Immaculate Heart of Mary Catholic Church was constructed at First and Maple Streets in August 1949. Local Catholics of the 19th century either traveled to Martinez or Antioch for services. Catholic churches were established early in the 20th century in Byron in 1917 and Oakley in 1906.

The Brentwood Chapel, dedicated on June 14, 1956, at a construction cost of nearly $100,000, provided a beautiful home for the Church of the Latter Day Saints community of 37 families and 136 members. The building was paid for by weekly dinners held at the Masonic Lodge and a lot of volunteer apricot cutting.

Five

COMMUNITY
WHEN WE BUILD IT . . .

Less than a dozen families were squatting, sharecropping, or otherwise dwelling on the Los Meganos land grant upon John Marsh's death in 1856. Marsh was constantly suing in the courts or attempting to physically dissuade families from encroaching on his property rights. A clear land title circumscribing the Marsh property to only 14,000 acres was provided with the first official survey of Rancho Los Meganos in 1853. Marsh's death, probate court, continuing Marsh family litigation, and debt liens made it easier for families in the east county to acquire land titles in the muddied waters of land litigation.

The Brentwood town site was created in 1877. James T. Sanford, principal of the Brentwood Coal Company and successor-owner of Rancho Los Meganos, sold several acres to the railroad for the establishment of a railroad right-of-way, train station, and town site. The first building, a blacksmith shop, actually precedes this sale by three years, with a building erected by Joseph Carey in 1874. E. Bacigalupi subsequently constructed a building and opened a saloon in 1876. Louis Gruneaeur erected a building to house a general merchandise store in 1880, completing the core downtown business district. A U.S. post office was established on November 9, 1878, with Clarence R. Esterbrook as postmaster. By 1882, the village had 100 residents, three stores, three saloons, a one-room schoolhouse, and a depot and adjacent warehouse. By 1900, the city dwellers had increased to 200, with hundreds living outside the city limits.

A key way to create community and provide social outlets is through popular fraternal organizations. The Brentwood Lodge of Masons, No. 345, was instituted in 1901 with 14 charter members. William Jerrisleu, a Jewish man from Southern California, traveled to the area for the sole purpose of establishing a Masonic Lodge and served as its first master. He found a welcoming community in Brentwood after his prejudicial experience with the Southern California Masons. The ladies embraced fraternal fellowship that same year, instituting Maspha Chapter No. 198, Order of the Eastern Star, with 22 members and Henrietta Stone as first matron. The Brentwood Women's Club was established in 1901 also with Henrietta Stone as president. It built the town's first library in 1915, landscaped the park, and mounted street signs in 1904, among other good works.

The ruined foundations of the Brentwood Coal Company (above and below) belie the considerable efforts to develop a commercial mining operation on the Marsh Grant from 1868 to 1877. Inferior-grade lignite coal mined at the black diamond mines in Somerville was consumed by industry in San Francisco, Stockton, and Sacramento. Speculation in mining and the creation of the Pacific Stock Exchange fueled interest in the Los Meganos coal mine in spite of a discouraging report from the Whitney Survey. James T. Sanford, the primary investor in the mine, subsequently filed for bankruptcy in 1875. Sensing the wheat-growing future of the area and perhaps a pressing need for cash, Sanford sold several acres to the San Pablo and Tulare Railroad for a train depot, railroad right-of-way, and township.

This real-photo postcard may show the sender in front of her own home. Traveling photographers were common from the 1890s to 1920. Once released from their studios, photographers with their boxy cameras and cumbersome equipment captured the everyday events of everyday people as no other media could.

The above postcard, the reverse of which is shown here, was sent from Brentwood to Mrs. A. F. Bray in Martinez on March 17, 1914. "Dear Leila, How did the medicine we sent fur [sic], help you? We haven't even it; write all about it. Missed you last night." The sender's signature is illegible. Leila Bray was the wife of the superior court judge and daughter of Sheriff R. R. Veale.

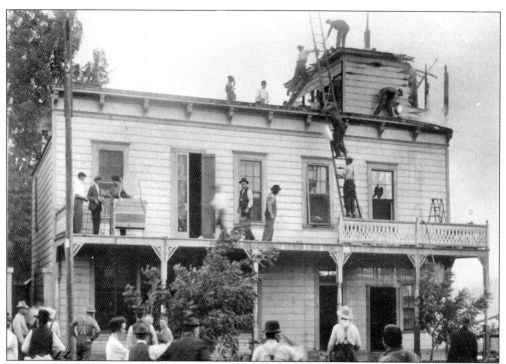

Boardinghouses are an important part of any growing town, particularly in the California immigrant world of single men and farm labor crews. The Diffin Boardinghouse burned in 1915 and was never rebuilt. It was located next to the Bank of Brentwood on First Street.

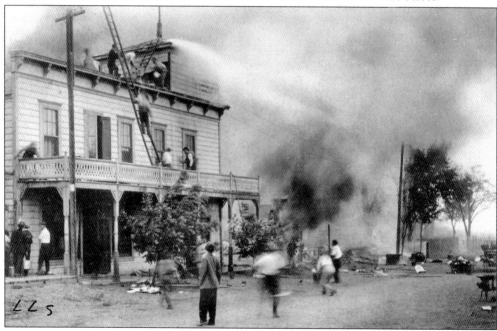

Looking carefully at this image, one can see a water bucket brigade in action. Brentwood did not have a fire truck or any method of delivering a jet of water to quench the flames. Water is passed up the ladder in five-gallon buckets. The fire was too great, and the building was destroyed.

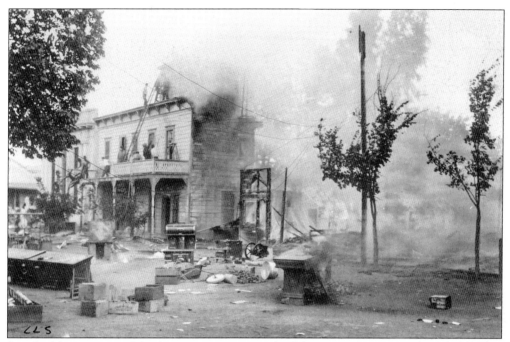

Standard fire response of the day was to move as much of the personal property out of the building as quickly as possible. Chances of halting a rapidly escalating building fire with buckets of water were slim. Minimizing the financial impact by saving the furniture and fixtures went a long way to reestablishing business.

The entire business block on First Street between Oak and Chestnut Streets was destroyed in the 1915 fire. Trembly hardware, the Pete Olson building, plus the Frank Golden, Hercules Logan, and M. Sargent residences were destroyed.

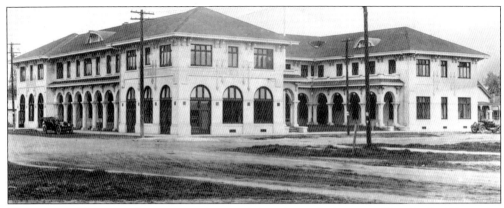

The streets of Brentwood were yet to be paved, but the optimism prevailing in the West prior to World War I was palpable. The industrial era had characterized 19th-century California, and people reacted by embracing a romanticized past in their everyday design. European art nouveau became the Craftsman school of design in the West, manifesting itself in popular Mission Revival buildings. The Hotel Brentwood was built in 1913.

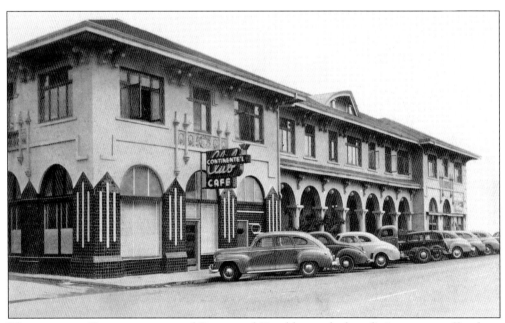

The two-story, 40-guestroom second Brentwood Hotel boasted a bar, dining room, coffee shop, and full liquor license. It was built in 1913 to impress potential investors in the developing community. Old-timers still remember when film star Roy Rogers walked into the Continental Bar, his horse Trigger waiting outside in the horse trailer.

An electric sign welcoming travelers announced one's arrival from what is now State Highway 4. The electric light bulbs spelling out *Brentwood* must have been an eerie sight on a typical tule fog night in winter when visibility can be limited to just 20 feet. It was easy to miss town even though State Highway 4 traveled down its six-block main street.

Located three miles north of town en route to Oakley along State Highway 4 was the Davis Automobile Camp. The owner provided a camp along Marsh Creek and within easy reach of the fields. The Davis Log Cabin Grocery extended credit, a very attractive policy to Depression-era laborers. Living in tents, their vehicles, or small cabins, the tenants were flooded out by the Marsh Creek floodwaters in 1950.

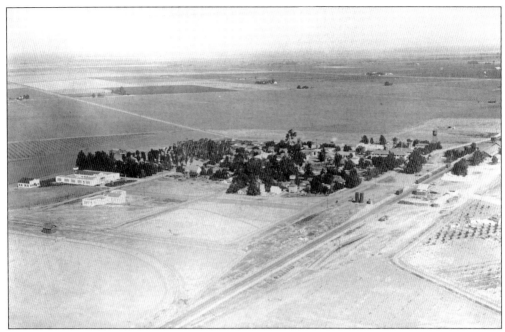

This 1929 aerial photograph of Brentwood shows clearly the major landmarks of the town. The new Liberty Union High School stands prominently in the north side, across from the new Brentwood Elementary School. The Brentwood Hotel is situated across from the Southern Pacific Railroad station.

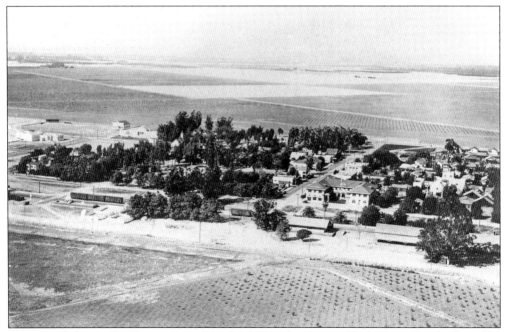

Brentwood's first orchards were planted by the O'Hara brothers in 1915. The orchards planted by Balfour, Guthrie and Company in 1922 are just beginning to produce fruit in this picture. The major trees are all introduced species of ornamental or fast-growing eucalyptus. The large valley oak trees have been removed for timber or fuel.

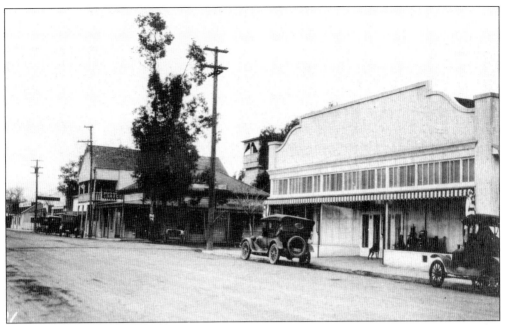

The west elevation of Oak Street (State Highway 4) is shown in the second decade of the 20th century. On the corner is the Bacigalupi Saloon, later sold to Jimmy Torre and now operating as Sweeney's Bar and Grill. At the end of the street is the Pioneer Ice Cream Parlor. During World War II, there were seven saloons between the railroad tracks and the city park.

This prominent glass and white stucco building is the original Morgan Davis Store, opened at First and Oak Streets in the 1870s. It held the post office, established in 1878, and housed the telephone company operator in the back. Rotary dial arrived in 1955. Brentwood phone numbers began as ME for Melrose (63), and one dialed just the last five digits for a local call. Antioch was long distance.

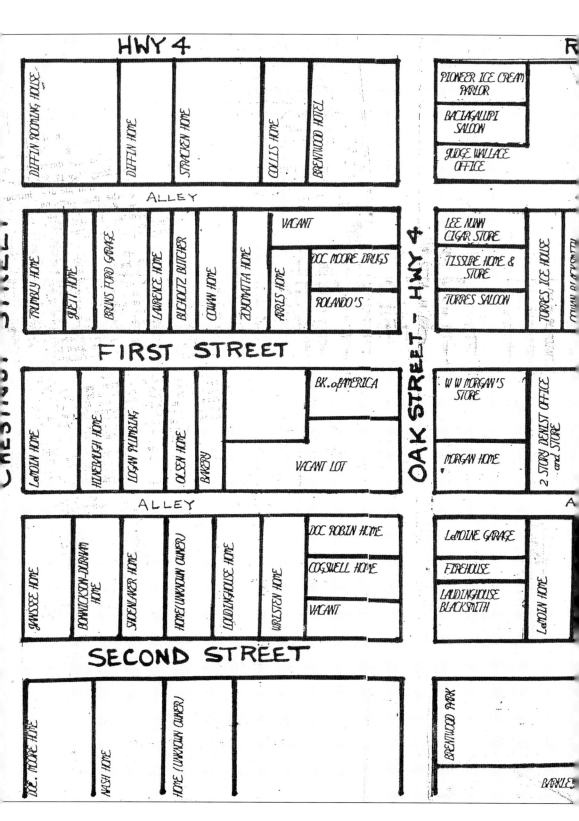

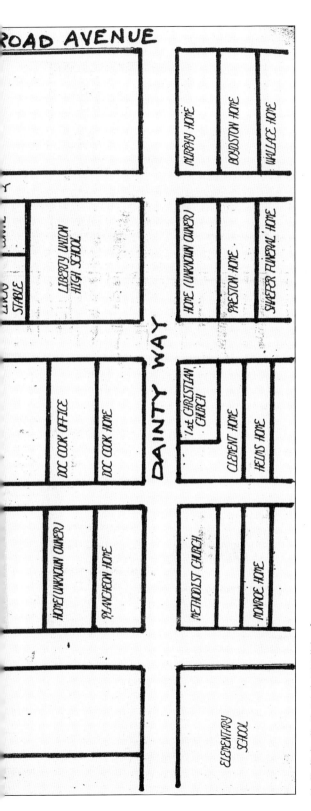

ROAD AVENUE

DAINTY WAY

MURPHY HOME

BOYDSTON HOME

WALLACE HOME

HOME (UNKNOWN OWNER)

PRESTON HOME

SHAFER FUNERAL HOME

LIVERY UNION HIGH SCHOOL

LIVERY STABLE

1st CHRISTIAN CHURCH

CLEMENT HOME

HELMS HOME

DOC COOK OFFICE

DOC COOK HOME

METHODIST CHURCH

MONROE HOME

HOME (UNKNOWN OWNER)

PLANCHEON HOME

ELEMENTARY SCHOOL

The Brentwood business district is pictured here in 1917, as first published by *Brentwood News* editor Sam Hill. Personal residences were interspersed with businesses, or their owners lived on the premises. There were more blacksmiths and garages than any other type of business in town. All buildings were located in a four-square-block area around Oak Street and Dainty Way. Third Street would not be created for another 20 years.

95

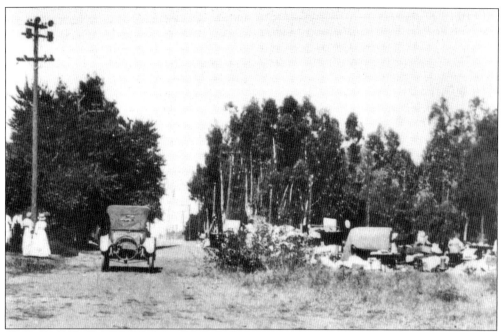

At the edge of town, behind the present city park, stood a large grove of eucalyptus trees. The area was a favorite squatters' campsite for transient farm laborers who could not be accommodated at the Balfour, Guthrie and Company camps or preferred not to pay for lodging at the Davis Auto Camp. This photograph was taken in 1914.

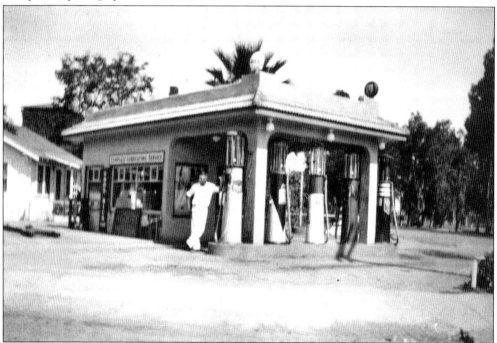

An early Shell oil and petrol station was owned and operated by Everett LeMoin, onetime town mayor. Next door on the right was the teenagers' favorite hamburger and malt shop, the Poppy Patch. Both were located on Brentwood Boulevard.

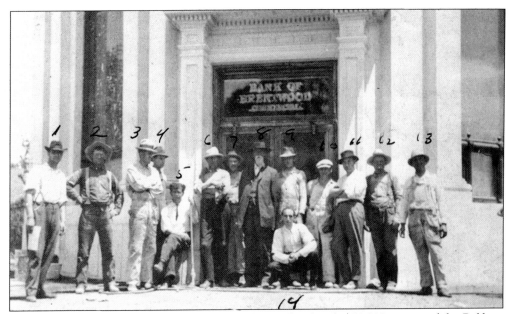

The Bank of Brentwood was incorporated and capitalized with $50,000 as part of the Balfour, Guthrie and Company plan to sell its early 13,000-acre Marsh Grant. It was a commercial (rather than retail) bank not surprisingly underwritten by the Balfour, Guthrie and Company interests in San Francisco. The building later served as a Bank of Antioch branch and then a Bank of America branch.

Local citizens did not grow their own food in a subsistence-farming manner. Area grocery stores did brisk business catering to both local homemakers and farmwives. This early Delta Markets advertisement, appearing in the February 7, 1964, *Brentwood News*, shows food prices comparable to those in the city.

DELTA MARKETS

OAKLEY · BRENTWOOD · BYRON

PRICES EFFECTIVE FRIDAY AND SATURDAY, FEBRUARY 7th and 8th

SUGAR CURED **BACON** By the Piece Pound	22c	SHOULDER **Pork Steaks** Pound	21c
PURE **LARD** Pound	9c	STEER BEEF, CHUCK **STEAKS** Pound	19c
GOLDEN RIPE **Bananas** 3 LBS.	14c	PORTO RICAN **Yams** 6 LBS.	15c
YELLOW GLOBE **Onions** 4 LBS.	9c	EXTRA FANCY WINESAPS **Apples** 6 LBS.	25c
TASTE TELLS **Tomatoes** 3 CANS FOR	25c	**Brooms** EACH	25c
VENCEDOR **Flour** 24½ LBS. 63c / 49 LBS. $1.23		WESTMINSTER 4 LBS. **Shortening**	39c
SILK **Toilet Tissue** 3 ROLLS	10c	CHESTY 4 CANS **Dog Food**	17c
L. C. SWEET **Pickles** 21 OZ. JAR	25c	BANNER 4 TALL CANS **Milk**	25c
DIABLO **Coffee** 2 LBS.	19c	**Saniclor** Plus Deposit ½-GAL.	15c
RIO DEL MAR, Oval Cans **Sardines** 2 FOR	15c	SPERRY'S Large Pkg. **Wheat Hearts** 5c Pkg. Raisins FREE	23c

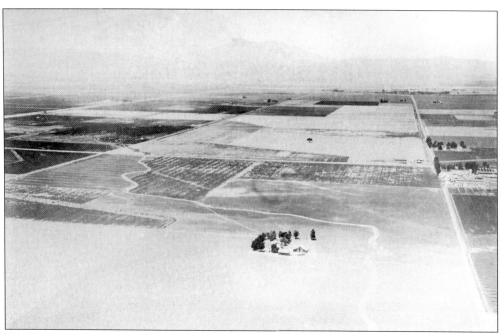

The Brentwood area experienced change between the above photograph, taken in 1929, and the below image, taken in 1970. Both perspectives show Marsh Creek flowing northeast from the foothills of Mount Diablo. The town of Brentwood is just visible on the right margin of the above image. Every farm and homestead seems a lonely outpost located on a section of land in 1929. In 1970, one has to look carefully to see small 20- to 40-acre fruit and nut orchards. Within the next 20 years, Brentwood would replace 100 peach trees to the acre with an average housing density of 10 houses to the acre.

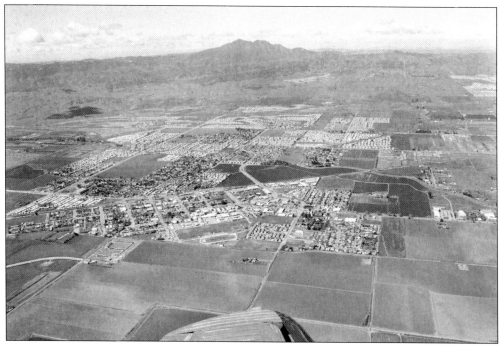

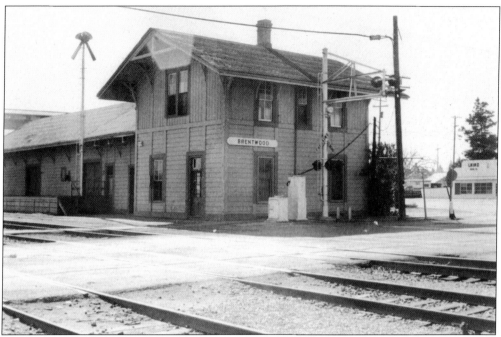

The Brentwood train station is shown here in its traditional Southern Pacific architecture painted yellow with brown trim. This regular stop on the original San Pablo and Tulare line continued as a stop on the Southern Pacific's San Joaquin line. Erected in 1878, it was demolished in 1980.

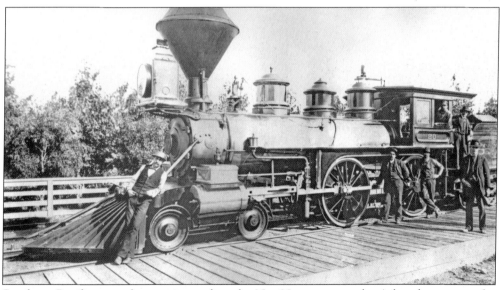

Southern Pacific steam locomotive and tender No. 20 are seen at the Arbor depot, near the intersection of Lone Tree Way and State Highway 4. Arbor did not include a station, but trains stopped at the depot to take on produce from the warehouse en route to their final destination at the Port Costa wharf.

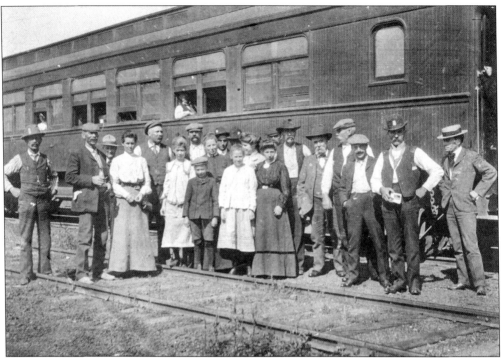

In 1904, members of the Prewett, Shellenberger, Williamson, and Glass families pose as they prepare to board a train at the Brentwood railroad station for a trip to the St. Louis World's Fair.

The last passenger train stopped in Brentwood in 1971. Diesel engines had replaced steam, but the train no longer made even a whistle stop for passengers. Only freight trains roll through Brentwood today and make no regular stops. Citizens must now travel to Martinez or to Stockton to board a train.

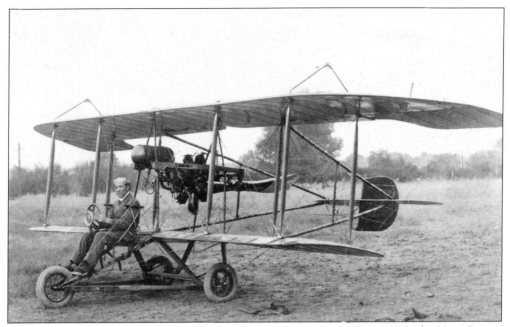

Aviation came to Brentwood early on with makeshift airstrips and rides given for $3. Here George H. Geddes pilots a biplane in 1906.

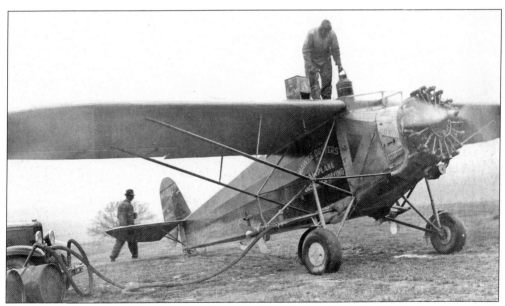

From the beginning, airplanes were used in agricultural service. This single-wing Hawk was built in Modesto specifically for crop dusting and was the first monoplane design in use. Notice the product arrived in premixed 50-gallon barrels with no warning labels—and certainly no protective masks for the ground crew or pilot during loading.

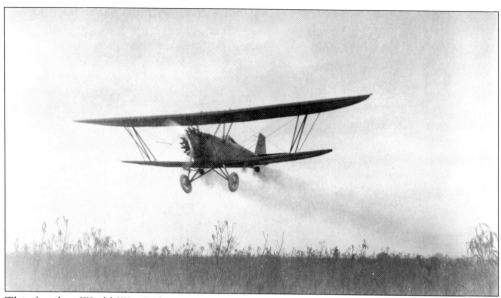

This familiar World War I plane was a favorite commercial crop duster. The plane carried a quantity of product and flew slowly, ensuring good coverage over the field or orchard. Its maneuverability helped it escape from the telephone poles inevitably found at the end of a field waiting to clothesline the unsuspecting pilot.

Farmers who continued to dry farm grain on the less-productive hillsides west of Brentwood had a welcome surprise in 1963, when large reserves of oil and natural gas were discovered. It is always easier to farm when you have an oil or gas well on your property.

Six

PUBLIC SERVICE

. . . WE WILL GET IT DONE

The community of Brentwood has traditionally accomplished its goals through the altruistic efforts of individual citizens and collaborative efforts of civic, social, or fraternal organizations. Once the basic physical infrastructure of the town was in place—thanks to Balfour, Guthrie and Company—the locals took over. The Masonic, Eastern Star, and IDES Men's Portuguese Lodge fraternal organizations, all established between 1900 and 1910, provided a social and ethical ground for community action. Informal or special-purpose committees came together to celebrate national holidays and organize apricot festivals, cornet band concerts, theatrical productions, and civic improvements. The Best of the West Club built a water fountain in front of the bank; a bandstand was constructed in the city park; and saloon keepers placed watering troughs for customers' horses.

Brentwood service organizations such as the Grange, Rotary, Lions, and Kiwanis Clubs were active, beginning with the Grange in the 1890s. The Lions Club, organized in 1929, raised sufficient funds to provide uniforms for the high school football team, hence the name Liberty Lions. The Brentwood Improvement Association, an early predecessor to today's chamber of commerce, was instrumental in Brentwood's incorporation efforts, resulting in the 1948 city charter. The Brentwood Womens' Club has been active for over 100 years. Its efforts include installing the first street signs, creating a reading room, fund-raising for streetlights, and other good works.

Youth was not to be outdone by its elders. Over the years, 4-H clubs and Future Farmer organizations provided a social and vocational outlet for teens. Boy Scouts of America, Girl Scouts of America, and Mariners all did their civic duty. Church youth groups completed the opportunities for developing good citizenship, as they continue to do today.

The political arena produced outstanding public servant Richard R. Veale, who was elected county sheriff in 1894 and served for 40 years. This record of public service as sheriff is the longest in the nation's history. Longtime county supervisor Joe Silva represented eastern Contra Costa County for many years as mayor, school board director, and supervisor. He retired only after leading eastern Contra Costa County toward its inevitable inclusion in the Bay Area Rapid Transit District (BART). His was the swing vote that placed Brentwood in the BART initiative in 1968.

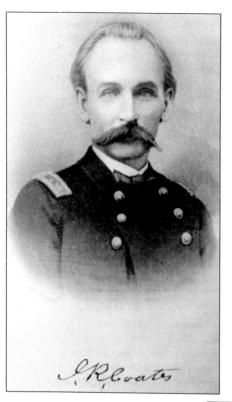

Civil War colonel J. R. Coats (1826–1915) traveled from Maine to California with the Gold Rush and succeeded in making a small fortune. After serving in Company A, 15th Regiment, Maine Infantry during the Civil War, Coats settled in Brentwood. During his service, he was wounded many times and served with distinction, rising to the rank of colonel. He is credited with constructing Coates Hall in 1900 for Masonic Lodge and community functions.

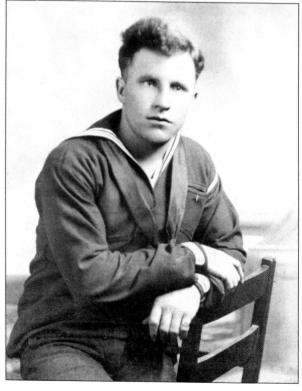

Charles Barkley, born in Vasco in 1894, was one of seven sons of pioneer Simon Barkley, all serving the community during their careers. A World War I navy volunteer, Charles subsequently served Brentwood as constable for 34 years.

American Legion Post 202 in Brentwood is named for this distinguished World War I army infantry volunteer, Melvin LeRoy Frerichs. He was the first Contra Costa County casualty of the war, killed on October 6, 1918. His remains are interred at the World War I memorial in Martinez.

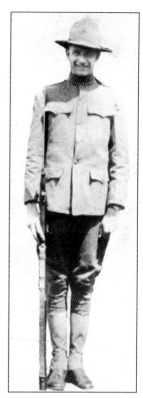

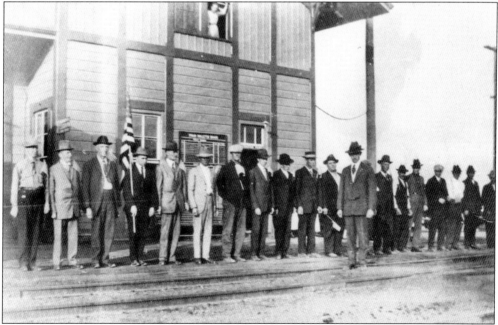

Those who did not serve abroad in World War I volunteered for the Home Guard. More than 80 men signed the roster in Contra Costa County. Alex Burrick (standing in front of the tracks) and the Brentwood Home Guard volunteers muster in front of the Brentwood train station in 1917 to keep the world safe for democracy and defeat the kaiser.

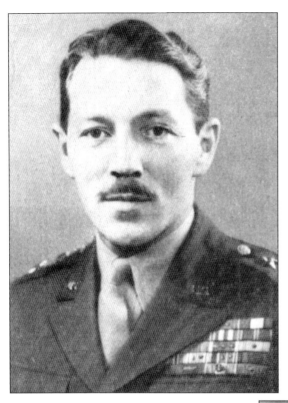

Maj. Gen. Robert T. Frederick, who retired to Brentwood after World War II to raise apricots, is the town's most famous serviceman. He commanded the 45th Infantry Division and created the 1st Special Service Force, also known as "the Devil's Brigade." Winston Churchill called Frederick the "greatest fighting general of all time" after he captured Monte la Difensa, Italy.

Contra Costa County sheriff Richard Rains Veale grew up on the Veale Land Tract and began school at Iron House. A local booster and public servant, Veale was elected to office first in 1894 and held the position for 40 years.

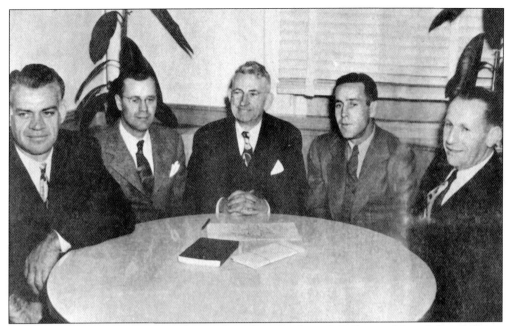

The first city council of Brentwood poses for a photograph in 1948. Pictured from left to right are Bob Jansse, Oliver Danielson, Jack Lane, Mayor John Dyer, and Adolf Boltzen. The city's first budget was $28,550. Its first assessed valuation was $700,000.

Behind the wheel of the Brentwood Fire Department pumper engine is police chief Bob Abney. Volunteer fireman Alan Jensen sells the chief tickets to the 1966 Fireman's Ball, an event held annually at the Veterans' Hall. Alan Jensen later served on the Brentwood City Council and as mayor from 1968 to 1970.

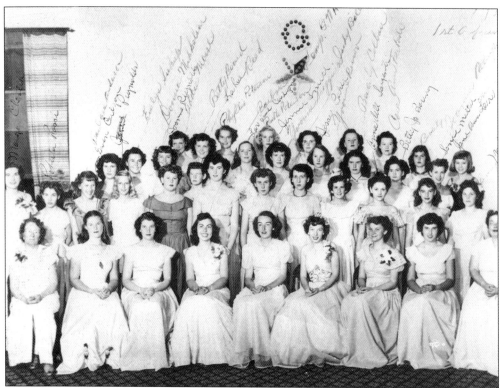

Order of the Eastern Star Maspha Chapter No. 198 members pose in this 1930s image. The chapter was founded in Brentwood in 1901.

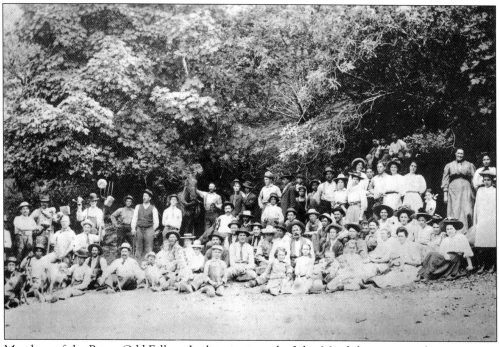

Members of the Byron Odd Fellows Lodge picnic at the John Marsh house grounds.

The John and Abigail Marsh Pioneer Monument was dedicated in 1932 by the Native Daughters of the Golden West, Donnor Parlor, Byron. Over 500 individuals attended the event. Sadie Brainard (left), past grand trustee of Sacramento, and Edna Hill (right), supervising district representative of Brentwood, pose alongside. The monument was rededicated by the Native Daughters 75 years later, in 2007.

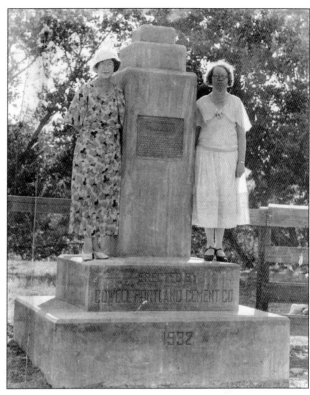

Fred Eachus established the *Brentwood News* as a weekly newspaper in 1897. He later sold the plant to E. W. Netherton, who started the *Brentwood Enterprise*. The printing plant had a series of owners and publishers before becoming home again to the *Brentwood News*, which remains the local newspaper today.

Sam Hill, editor, publisher, and owner of the *Brentwood News*, acquired the paper from H. W. Bessac in 1920. By that time, the paper had a circulation of 650 readers. Sam is perhaps best known for his controversial editorials and to longtime residents as the husband of grade school teacher Edna Heidorn Hill.

Judge W. Blair Rixon arrived in Brentwood in 1945 and was the only attorney in town. Once the township incorporated, Rixon was appointed a judge in Delta Municipal Court in 1948 and served until 1974, when the municipal court was dissolved and moved to Pittsburg.

The new Liberty Union High School is dedicated by members of the Masonic Lodge in 1965. Grand master Bernard Callahan (in top hat) presides over the event. (Courtesy of Gene Clare.)

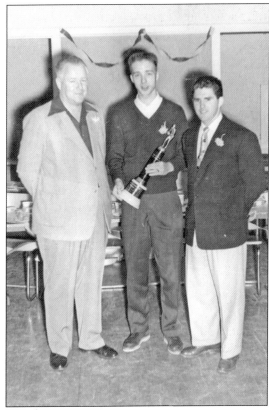

From left to right, Judge Ted Olmsted, Jerry Vonder, and coach Bill Ferrill participate in the 1954 Rotary Student Athlete of the Year program. (Courtesy of Jack Ferrill.)

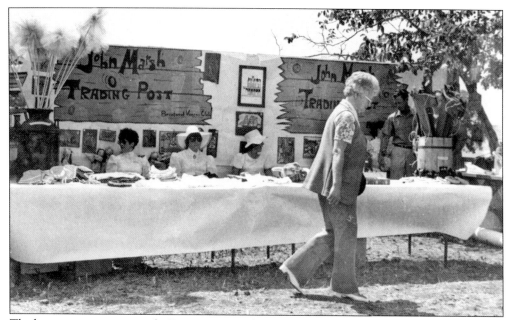

The last community picnic, the Romeria enjoyed at the great Stone House grounds, raised $10,000 for the restoration of the historic building. The John Marsh Memorial Association, chartered by Contra Costa County and chaired by newspaperman Bob Gromm, began the effort in 1972 to save the landmark from ruin. Concerned individuals are still trying to save the John Marsh house more than 35 years later.

This hitching post, pictured in 1968, is located at the end of the BART line in Brentwood. Initial plans for BART service did not include eastern Contra Costa County, although the communities would pay the special district property tax. Creation of this BART hitching post politically expresses the quality service local citizens expected to receive.

Seven

GOOD TIMES
SEE YOU AT THE CORNFEST

Life cannot get much better than living in the California Delta. Brentwood's proximity to the famed "1,000 miles of waterways" and salubrious climate encourage year-round recreation. The 103-degree August days find every child who can swim frolicking in the water and showing off his perfect suntan. Powerboating and waterskiing first captured residents' passion when the hobbies were introduced to the West by Ni Orsi Sr., his sister Elsie, and Holly Thorn of Stockton in 1936. A favorite individual project in Liberty High's woodshop class was the creation of mahogany and later laminated-wood single or double sets of water skis. World-champion slalom and trick water ski experts regularly complete at Orwood Resort, along Old River, and in private sloughs.

Fishing for sport draws locals to the water for recreation and dinner. Many young people have delighted in their first catfish, bluegill, or flounder caught from the brackish waters with only a hook, worm, and sinker attached to a bamboo pole cut from the levee. The best striped bass fishing in the world is found among the submerged islands along the San Joaquin River. Millions of migratory birds fly overhead between their Canadian summer home and Mexican or Central American winter habitat. Duck hunters and bird watchers alike await the annual migrations. The uncultivated margins and straight rows of sugar beet fields are natural hiding areas for the ring-necked pheasant, imported from Asia to California for sport in 1857.

The best times occur when friends and family come together at community events. The Brentwood City Park, located in the center of town, has hosted many events over the years. The Diablo Valley Apricot Festival, held in the 1930s, brought farmers, laborers, and consumers to celebrate summer fruit in July. Many recall the Lions Club Carnique celebration, held every Fourth of July beginning in 1953, and its concluding July 1977 fireworks display. The highlight of the event was the raffle of a beautiful new Ford automobile provided by the local Earline Chapman Ford dealership. The Harvest Festival resumed the community tradition in 1988. More recently, the Cornfest, centered on the delicious local sweet corn, has combined automobile shows, barbecues, and fun for all since 1992.

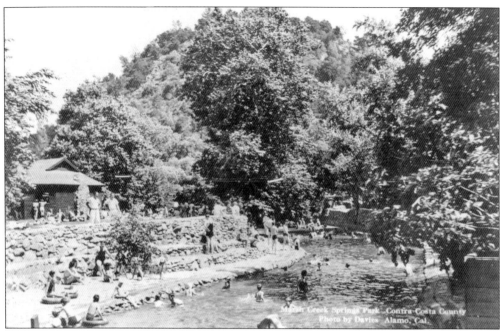

Gerald L. Gill created Marsh Creek Springs from 90 acres of swampy land in 1927. He proceeded to develop his own dream recreational park from the riparian woodland and Marsh Creek. The facility included two swimming pools, children's wading pools, a livery stable, baseball diamonds, a dance floor, and other amenities.

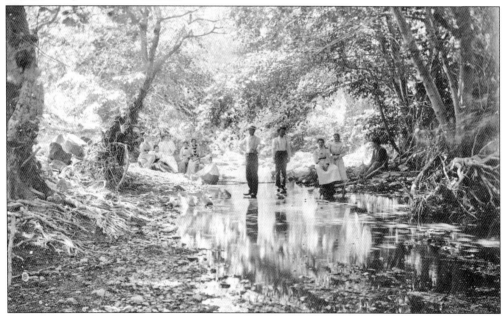

By 1940, Marsh Creek Springs sprawled across 210 acres and could accommodate 5,000 visitors a weekend. Attendance boomed in 1938 with 180,000 guests from all over the San Francisco Bay Area. Sadly a 12-foot wall of water flowing down Marsh Creek destroyed most of the infrastructure in 1957. The rebuilt park was washed out once more in 1962 and closed. It is open once more for picnics and weddings.

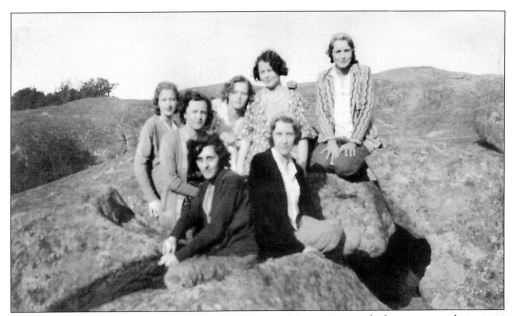

A social group of Livermore girls in search of Joaquin Murrieta's cave hideout visit and picnic at Brushy Peak in March 1931. The fashionable adventurers wear skirts, bobbed hair, and hand-knit sweaters. Two of the girls will marry and make their homes in Brentwood: Dorothy M. Jensen (front right) and her sister Vita A. Jensen Normann (rear right).

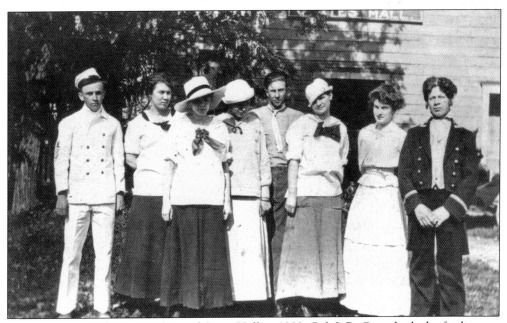

The cast of *Mr. Bob* poses in front of Coats Hall in 1908. Col. J. R. Coats built the facility as a Masonic hall specifically at the request of the first grand master, Will Jerrisleu. The brothers met upstairs, and the downstairs area was reserved for community events like this play.

Tennis was a popular sport for both men and women in the 1920s. Important players perfected their skills on Brentwood and Byron Hot Springs courts. One of the most famous is Helen Wills, a Byron Hot Springs resident who twice became an Olympic champion and was an eight-time women's singles Wimbledon champion.

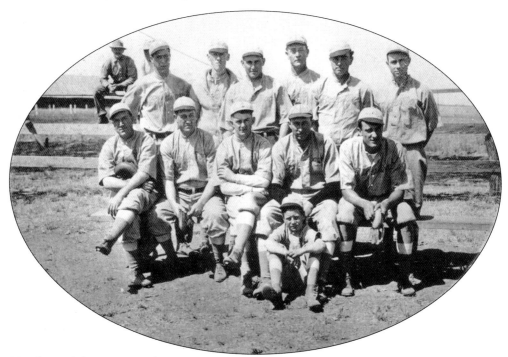

Members of the Brentwood community baseball team appear in their white pinstripe home uniforms. All the local communities had teams that were very competitive with each other. Brentwood challenged Byron, and Oakley challenged Knightsen.

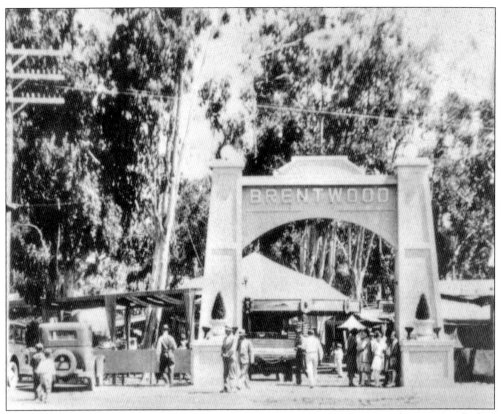

Brentwood City Park, originally called Brentwood Grove, was a gift of Josephine L. Sanford in 1888. She was heir to the interests and property of John Sanford, the major shareholder of the Brentwood Coal Company. The welcoming arch was constructed by J. W. Williams in 1929.

Horseshoe champions are seen at the Apricot Festival competing for significant prizes. Side bets were placed, and great pride was taken by the winning team.

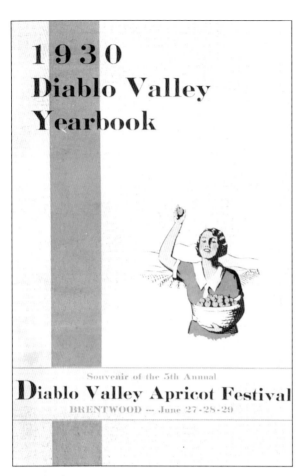

1930 Diablo Valley Yearbook

Souvenir of the 5th Annual
Diablo Valley Apricot Festival
BRENTWOOD — June 27-28-29

The Diablo Valley Apricot Festival began in Antioch, moved to Oakley, and was held in Brentwood from 1927 to 1936. This 1930 Yearbook souvenir has its equivalent in the Harvest Time in Brentwood trail map distributed today. Interior maps show the location of "U Pick" fruit stands and promote the area.

Pictured here are a souvenir blue ribbon and a gold-lettered 1930 Apricot Festival participant badge with clasp.

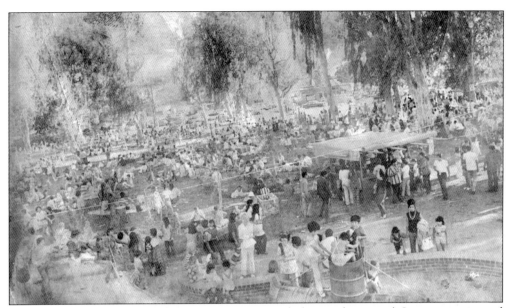

This mid-1950s overhead view of Brentwood City Park depicts the annual Carnique sponsored by the Lions Club.

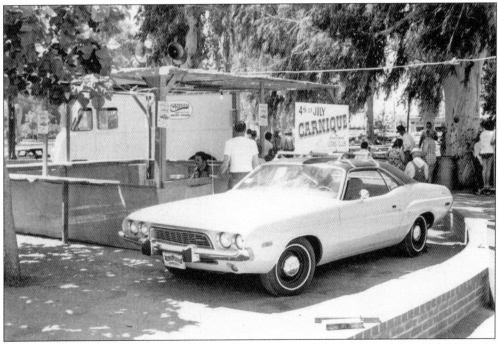

The local Ford dealership, owned by Earline Chapman, provided this convertible, which was given away as the grand prize of the Carnique. Funds raised by ticket sales defrayed event expenses and went to the good works of the Lions Club.

This "after the hunt" photograph shows a proud group of local farmers and huntsmen with their prize of ring neck pheasants and their bird dogs. Sugar beet fields and levee margins are prime habitat for game birds. Migrating fowl attracted to the waterways and grain fields provide the best sport hunting in the state.

Driver Diana M. Thomas poses with her father, Frank Thomas, in October 1959. This midget Indianapolis racecar received the trophy for the prettiest car on the California and Nevada racing circuit. Diana was the first and only female racer at the circuit. She consistently waved to the boys and made them cry as she passed to win the race.

After a day of fishing, hunting, or playing horseshoes, men settle down inside for indoor sports and refreshments. Cards were a favorite pastime in the back room.

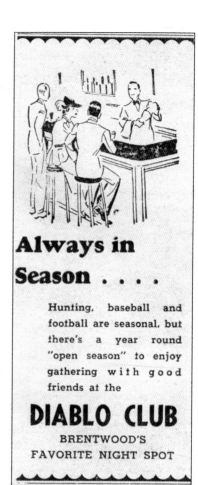

Jim Torre's horse trough is gone, but the Diablo Club (or Sweeney's, as it is now known) dates back to 1878.

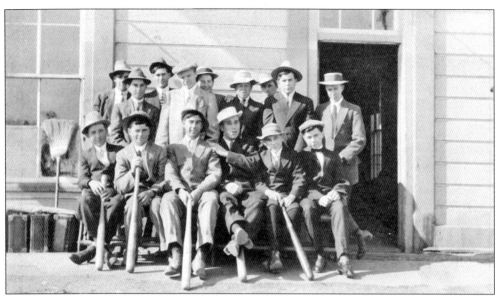

Bearing luggage, the Brentwood baseball team returns home after a clean sweep of games, as indicated by the upturned broom on the left.

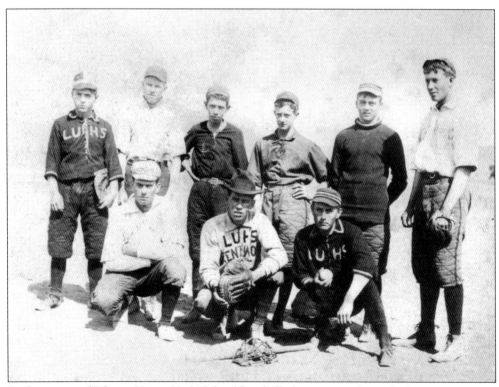

In this image of Liberty Union High School baseball players, note the quilted pants to ease in sliding home.

The first Colonel Corn, Byron Bonnickson, is pictured at the first Cornfest in 1992. He wears a custom costume with epaulets of popped corn and a pith helmet in this promotional photograph.

The Brentwood Carnique featured the sweetest yellow corn. The spirit of this early community celebration continues today in the Cornfest. Here local volunteers begin individual shucking of the tons of corn ears consumed during this one-day event.

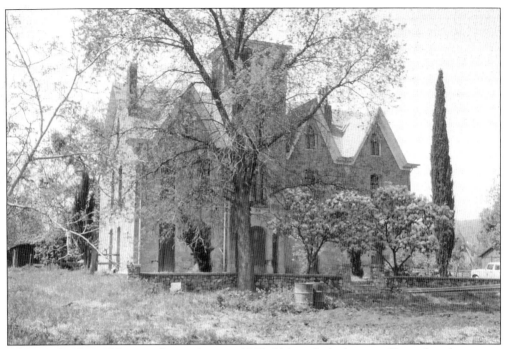

John Marsh's Stone House is shown above in 1966. Although the house still stands today, it is in severe disrepair. The City of Brentwood, the John Marsh Historic Trust, and local and statewide organizations are dedicated to its full restoration to 1860s elegance. Restoration symbolizes the community's effort to reclaim its role in state history and to underscore the important role Brentwood continues to play in the state economy. When completed, the Stone House will be the crown jewel of the largest state historic park in California: the 3,659-acre John Marsh State Historic Park. (Below courtesy of Frank Vranek, Grand Humbug, E Clampus Vitus, Joaquin Murrieta Chapter No. 13.)

DR. JOHN MARSH'S
RANCHO LOS MEGANOS

THIS MONUMENT MARKS THE TERMINUS OF THE FIRST OVERLAND IMMIGRANT TRAIL TO CALIFORNIA FROM THE UNITED STATES. THE BARTLESON/BIDWELL PARTY COMPRISING 30 MEN AND ONE WOMAN WITH HER BABY ARRIVED AT DR. JOHN MARSH'S RANCHO LOS MEGANOS IN NOVEMBER 1841. MARSH WAS THE FIRST TO PUBLICLY ENCOURAGE EMIGRATION TO CALIFORNIA. LIVING AT THE MARSH RANCHO WERE A NUMBER OF NATIVE MIWOK PEOPLE. AN ELDER OF THE TRIBE LED THE WEARY IMMIGRANTS TO THE SAFETY OF THE MARSH ADOBE. THESE EARLY AMERICAN PIONEERS WERE THE FIRST TO REACH CALIFORNIA BY LAND, BEGINNING THE MOVEMENT INITIATED BY DR. JOHN MARSH TO BRING CALIFORNIA INTO THE UNION.

DEDICATED NOVEMBER 3, 2007
JOHN MARSH HISTORIC TRUST
JOAQUIN MURRIETA CHAPTER #13
E CLAMPUS VITUS

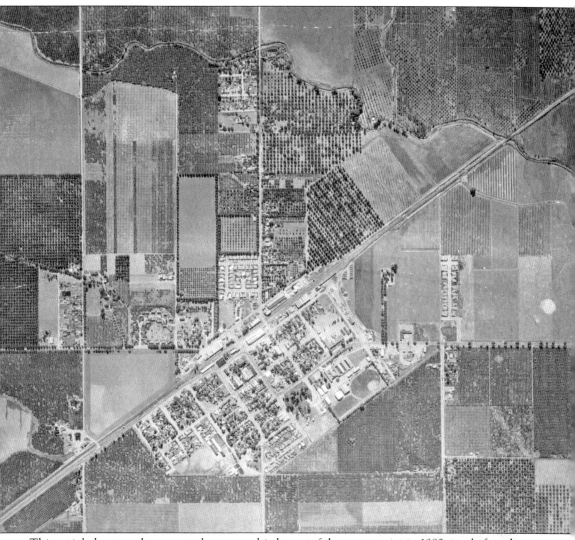

This aerial photograph captures the geographic layout of the community in 1992, just before the suburban housing boom of the 1990s. The core town is surrounded by fruit and nut orchards, row crops, and open space.

TIMELINE

9000 BCE Native Americans begin occupation of this region of California.

1772 CE Spanish explorer Capt. Pedro Fages discovers this part of California.

1837 Dr. John Marsh purchases the Los Meganos Rancho.

1841 The first immigrants, members of the Bidwell party, arrive at John Marsh's home on Marsh Creek Road.

1856 John Marsh is murdered in Pacheco en route to Martinez.

1863 The U.S. Land Commission confirms the borders of Rancho Los Meganos.

1865 The Liberty School, a one-room grammar school, is established on Marsh Creek Road.

1867 The Brentwood coal mine opens.

1867 The Lone Tree School is established. It merges with Brentwood in 1959.

1869 The Deer Valley School is built and merges with Brentwood in 1918.

1874 Louis Grunauer and Joseph F. Carey found the first businesses in Brentwood.

1876 Charles Marsh loses Rancho Los Meganos to bank foreclosure.

1876 Brentwood's first saloon is opened by E. Bacigalupi.

1878 The San Pablo and Tulare Railroad comes through town.

1878 The Brentwood Post Office is established.

1879 The Brentwood School is created.

1881 The first map is filed for Brentwood as a township.

1884 The Brentwood Hotel is built by Louis Grunauer. It burns down on November 29, 1903.

1888 The Sanford family donates land for Brentwood City Park.

1890 Brentwood becomes the largest shipping point for grains west of New Orleans.

1900 Balfour, Guthrie and Company begins acquisition of the Marsh land grant.

1905 Liberty Union High School has its first graduation with Edith A. Sellers as the only graduate.

1905 Brentwood's first high school is built on the corner of First and Maple Streets.

1913 Balfour, Guthrie and Company constructs the new Hotel Brentwood.

1913 The Bank of Brentwood is built.

1913 Balfour, Guthrie and Company maps the town and subdivides farmland.

1920 A new Liberty Union High School is built on Second Street costing $93,000.

1922 Brentwood's first orchards are planted.

1924 Rural free mail delivery begins in Brentwood, serving 115 homes.

1926 The first Apricot Festival is held.

1926 H. P. Garin comes to Brentwood and leases 600 acres. By 1935, Garin controls more than 30,000 acres in the state.

1926 By an overwhelming vote, the residents of Brentwood establish the first Contra Costa Water District to serve the town with a domestic water supply.

1928 The Brentwood Fire Department organizes, with Clyde Watson as the first chief.

1929 The H. P. Garin Company has 3 packing sheds and 22 cottages for its employees. The firm ships 794 carloads of fruits and vegetables and uses the first refrigerated railroad cars.

1930 Balfour, Guthrie and Company has the state's largest dry yard and packing shed.

1934 The Apricot Harvest Strike hits Brentwood.

1943 Brentwood Irrigated Farms (Balfour, Guthrie) sells its last holdings to Tom Peppers of Mentone.

1948 Brentwood incorporates. John Lane is the town's first mayor.

1953 The first Lions Club Carnique is held. This annual event serves as the Lions' primary fund-raiser until 1977.

1963 The central portion of Liberty Union High School containing the administration offices burns down.

1967 The Brentwood Hotel is razed to make way for a new service station.

1970 The East Contra Costa Historical Society is founded. Walter Sharafanowich is the first president.

1971 The last passenger train passes through Brentwood.

BIBLIOGRAPHY

Bohakel, Charles A. *The Indians of Contra Costa County: The Costanoan and Yokuts Indians.* Amarillo, TX: P&H Publishers, 1977.

Bolton, Herbert E., ed. *Fray Juan Crespi: Missionary Explorer on the Pacific Coast, 1769–1774.* Berkeley, CA: University of California Press, 1927.

DeMartini, Carolyn. *The Brentwood Hospital: A Rural California Hospital and Its Environs 1929–1931.* Concord, CA: Concord Graphics Arts, 1999.

Emanuels, George. *California's Contra Costa County: An Illustrated History.* Fresno, CA: Panorama West Books, 1986.

Emerson, Kathy. *Iron House School.* Lodi, CA: Abrahamson Printing, 1984.

History of Contra Costa County, California, with Biographical Sketches. Los Angeles: Historic Record Company, 1926.

Hohlmayer, Earl. *Looking Back II Tales of Old East Contra Costa County: An Illustrated History.* Antioch, CA: E&N Hohlmayer, 1996.

Hulaniski, Frederic J., ed. *The History of Contra Costa County, California.* Berkeley, CA: Elms Publishing, 1917.

Illustrations of Contra Costa County. Oakland, CA: Smith and Elliott, 1878.

Jensen, Carol A., and the East Contra Costa Historical Society. Images of America: *Byron Hot Springs.* Charleston, SC: Arcadia Publishing, 2006.

———. Images of America: *East Contra Costa County.* Charleston, SC: Arcadia Publishing, 2007.

Jensen, Carol A., from the archives of Hal Schell and the East Contra Costa Historical Society. Images of America: *California Delta.* Charleston, SC: Arcadia Publishing, 2006.

Leighton, Kathy. *Footprints in the Sand: The City of Brentwood and East Contra Costa Historical Society Publication.* Ann Arbor, MI: Sheridan Books, 2001.

Leighton, Kathy, and Carol A. Jensen. *Betcha Didn't Know: Little Known Facts of East Contra Costa County.* San Francisco: Nomad Printing, 2004.

Lyman, George D. *John Marsh Pioneer: The Story of a Trail Blazer on Six Frontiers.* Chautauqua, NY: Chautauqua Press, 1931.

Munro-Fraser, J. P. *History of Contra Costa County, California.* San Francisco: W. A. Slocum and Company, 1882.

Noble, Vernon C. *Liberty Union High School: A Memoir.* Ann Arbor, MI: Sheridan Books, 2001.

Purcell, Mae Fisher. *History of Contra Costa County.* Berkeley, CA: Gillick Press, 1940.

Tatam, Robert Daras. *Old Times in Contra Costa.* Pittsburg, CA: Highland Publishers, 1993.

University of California Publications in American Archaeology and Ethnology, Vol. 23, No. 2. Berkeley, CA: University of California Press, 1926.

OTHER RESOURCES

Bay Area Office of the California Department of Water Resources. baydeltaoffice.water.ca.gov

Contra Costa County Historic Landmarks Advisory Committee. www.co.contra-costa.ca.us/depart/cd/administration/hlac.htm

Contra Costa County Historical Society, 610 Main Street, Martinez, CA 94553. www.cocohistory.com

Delta Wetlands Project. www.deltawetlands.com

East Contra Costa Historical Society and Museum, 3890 Sellers Avenue, Brentwood, CA 94513. www.theschoolbell.com/history

John Marsh Historic Trust. www.JohnMarshHouse.com

San Francisco Bay Area Postcard Club, PO Box 621, Penngrove, CA 94951. www.postcard.org

ACROSS AMERICA, PEOPLE ARE DISCOVERING SOMETHING WONDERFUL. THEIR HERITAGE.

Arcadia Publishing is the leading local history publisher in the United States. With more than 4,000 titles in print and hundreds of new titles released every year, Arcadia has extensive specialized experience chronicling the history of communities and celebrating America's hidden stories, bringing to life the people, places, and events from the past. To discover the history of other communities across the nation, please visit:

www.arcadiapublishing.com

Customized search tools allow you to find regional history books about the town where you grew up, the cities where your friends and family live, the town where your parents met, or even that retirement spot you've been dreaming about.